名师绘画技法系列丛书

高冬／主编

吴兴亮水彩艺术
WATERCOLOR BY WU XINGLIANG

中国林业出版社

图书在版编目（CIP）数据

吴兴亮水彩艺术 / 高冬主编. -- 北京：中国林业出版社，2011.11
（名师绘画技法系列丛书）
ISBN 978-7-5038-6351-6

Ⅰ. ①吴… Ⅱ. ①高… Ⅲ. ①水彩画–绘画技法Ⅳ. ①J215

中国版本图书馆CIP数据核字(2011)第206201号

名师绘画技法系列丛书·吴兴亮水彩艺术
主　编　高冬

策划编辑	吴卉　牛玉莲
责任编辑	吴卉
封面设计	高冬　周亮
摄　　影	彭浩
出版发行	中国林业出版社 邮编：100009　　　地址：北京市西城区德内大街刘海胡同7号 电话：83224477　　E-mail: jiaocaipublic@163.com http:// lycb.forestry.gov.cn
印　　刷	北京雅昌彩色印刷有限公司
经　　销	新华书店
版　　次	2012年1月第1版
印　　次	2012年1月第1次印刷
开　　本	889mm×1194mm　1/16
印　　张	5.5
字　　数	290 千字
定　　价	68.00元

凡本书出现缺页、倒页、脱页等质量问题，请向出版社图书营销中心调换

版权所有　侵权必究

序

清华大学高冬教授主编的当代水彩艺术《名师绘画技法系列丛书》嘱我写序。他认为我在绘画艺术和设计艺术的关系方面的一些论点很合他的意图，因此，将《吴良镛"画记"》所写的序言和跋的一些文字凝练成一篇文章拟作为本《丛书》的序。我看了一遍，那是10年前即将度80岁为出画集时所写的文章，看当时的激情，现在再要我作恐怕难以写出来，但文章可以参考，可以作"吴良镛论绘画"附录于后。因此决定专写一篇。

这些年来由于计算机的进步，为建筑图的制作提供了极大的方便，制作建筑渲染图无论技巧、表现能力，都有了意想不到的提高。一般竞赛的建筑表现图几乎看不到大型的水彩渲染图，可能也出于同样原因，学生对水彩画练习的兴趣，由于照相机和计算机性能的进步，所应具备的建筑师的速写习惯也减退了。我个人对这种现象有如下的看法：

1. 对于计算机制图的进步与普遍地推广运用，这毋庸置疑。它的建筑艺术创作，也需要多方面的艺术修养。

2. 手绘建筑画的表现技巧并不因上述情况而否定。举一个例子：清华大学建筑学院前景观系主任 Laurie D.Olin（欧阳劳瑞），他是美国艺术与科学院院士，在传授他的园林建筑设计作品时最后总要放映他设计作品的水彩画表现图。我每次见到均颇为欣赏，不仅技巧好，寥寥数笔对设计内容表现得淋漓尽致，并且他所表现的对象充满阳光和所在环境的空间层次感、色彩感给人以美的享受。这种诗情画意的表达、这种艺术境界的取得取决于美术修养，不是计算机制图所能达到的。

3. 照相技术的进步大大提高摄影水平，这为建筑师提供了方便，但照相机只是工具，关键要看建筑艺术修养。从建筑师使用它我注意到一种情况，尤其在旅游团组织越来越普及的情况下，日程安排很紧去很多地方，于是照相机咔嚓咔嚓……照了很多照片回来，这不是没有用，但作为建筑师速写这一环节却每每被略去了，这是很可惜的。

摄影艺术是特殊门类，照相机照观赏对象与建筑用速写的方式记录一个对象效果是不一样的。速写是通过眼的观察、取景、选择，然后再到用手记录下速写稿，成为一幅画。即使是最潦草的一幅画，它也是一幅画作，好的话它还是一件艺术品。即使是一幅不完整的艺术品，它也是对你观察的对象一个完善的欣赏练习过程，比照相机记录内容充实多了、丰富多了。一个建筑的学习者如果失去了这个训练是可惜的，而且是无法弥补的。以我个人的经历为例，我跑过不少地方，有的做了速写，有的仅做了摄影甚至连像也未照，凡是做了速写的，至今几十年后甚至半个多世纪以后仍历历在目，而一般照相不免模糊甚至遗忘了。

高冬教授主编《名师绘画技法系列丛书》是件很有意义的事情，该系列丛书选了十几位国内著名水彩画家的代表作品，每人一集，他们的艺术代表了我国目前水彩艺术的整体水准，又多是从事水彩艺术教学的教授、专家，其画作的艺术就不用我辍言了。希望通过这套《丛书》的出版，能让我们的青年和学生在水彩艺术的表现技能和艺术修养方面有所提升。

中国科学院院士
中国工程院院士
吴良镛
2010年9月3日

Preface

I have been requested to write a preface for *The Serial Books of Painting Skills by Famous Masters* for contemporary watercolor art compiled by Professor Gao Dong of Tsinghua University. He thinks that a few ideas of mine concerning relations between painting art and designing art are in line with his own intentions. So he mixed some words of the preface and postscript in the Remarks on *Wu Liangyong's Picture Album* and rewrote an article to be used as the preface for the book. When I read it, I found that those words were written ten years ago for my picture book that would be published prior to my 80th birthday. I am afraid that it is difficult for me to write such an essay based on the passion at that time. But the essay could be used as a reference and attached to the book as *Comments on Paintings by Wu Liangyong*. Therefore, I have decided to write a new one.

Thanks to progress made by computer technology in these years, computer can provide great convenience for architecture drawings. Techniques and expressivity of architectural rendering have been improved in an unexpected way. It is seldom to see large-sized color renderings in general architectural competitions. Students lose their interest to practice watercolor and their sketching habit to become an architect, due to high performance of camera and computer. Personally, I have my own opinions as follows.

1. It makes no question of the advancement in computerized drawing and its wide application. Creativity of architectural art needs training in many respects.

2. The expressive techniques of architectural paintings by hand will not be denied owing to the above mentioned. For example, as an academician of American Academy of Arts and Sciences, Mr. Laurie D. Olin, a former dean of landscape department of architecture college of Tsinghua University, would always show his watercolor expressions for his designs when he taught his garden architecture. I would be appreciated each time when I saw these works which were not only fine with just a few lines for most expressive, but also offered enjoyment of beauty with a sense of space and color for the object. The poetic expressions depend on art accomplishments, but not from computer drawings.

3. The advancement of photography has greatly improved photographic level, which provides convenience for architects. However, camera is only a kind of tool. The key point relies on art accomplishment of architecture. I

have noticed a fact that architects use cameras. When tourism gets more and more popular and traveling destinations become so many, cameras turn out to be more efficient to produce a lot of pictures. This is not useful, yet it is pitiful that sketches for architects are neglected.

Photography belongs to a special class of art. It is different from recording an object with a sketch for architecture to viewing an object through a camera. A sketch is a painting resulted from observation and selection to record by hand. Even if it is made in a hurry, the sketch is a drawing. If it is good, sometimes, the sketch will become a piece of art works. A sketch is a perfect process of practice for your observing an object, which contains full and rich information compared with record by camera. It is to be regretted for an architecture learner to lose this opportunity of training that can not be made up. Take my own experience for an example, I have been to many places where I had sketches, took photos or even no pictures. Those things in sketches are still vivid in my mind decades of years later or even half century passed. But I cannot remember clearly or have simply forgotten those with photos.

It is significant for Professor Gao Dong to edit *The Serial Books of Painting Skills by Famous Masters*. Representative works of dozens of watercolor artists famous at home are selected in the serial books, one book for each painter, which represent the watercolor artistic level of China at present on the whole. Most of these painters are professors or experts engaged in teaching of watercolor art. It is unnecessary for me to comment on their works. I hope that when the serial books are published, expressive techniques and artistic appreciation of watercolor art for the youth and students will be enhanced.

Wu Liangyong
Academician of Chinese Academy of Sciences
Academician of Chinese Academy of Engineering
September 3, 2010

吴良镛论绘画

一般来说，建筑师把习画作为建筑学习的一部分，即训练徒手画的表现技巧，以得心应手地表现建筑的构图、质地、光影，以及自然环境等。这方面奥妙无穷。只要看一看梁思成、杨廷宝、童寯等先生的建筑画，以及西方建筑师的草图（例如宾夕法尼亚大学建筑档案馆所藏的路易·康等人的手稿，1987年在巴黎蓬皮杜中心举行的柯布西耶百年展陈列的他早年意大利之行的速写与水彩），你就不能不为其飞动的线条、斑斓的色彩背后闪现的灵感与创作思想所感动。现代的制图工具与计算机技术发展很快，甚至达到了准确如实物摄影的程度。但对比前辈大师，现在建筑学人中徒手表达能力有削弱的趋势，对此，我感到困惑。就我个人来说，并不满足于建筑表现技术的学习，而是希望从习画中加强对艺术和文化的追求。我发现有些以建筑为题材的绘画要比一般建筑画更富意境。例如在西方一些大博物馆中几乎都可以看到描写威尼斯圣马可广场以及一些名都圣地的画，它不仅是建筑的表达，更是风情的记录。自文艺复兴后透视术的发明，表达建筑构想的画多了起来，有所谓"建筑幻想图"（architectural fantasias），例如，18世纪Piranesi早期铜版画，德国古典艺术大师辛克尔（Schinker，身兼建筑家、画家、雕塑家、工艺美术家、建筑教育家）把建筑、风景的描写与遐想以游戏之笔作舞台布景的构图，独辟蹊径；在中国，如《清明上河图》《千里江山图》《姑苏繁华图》等，一般我们也不把它作为建筑画来欣赏，而是看作当时城市文化和大地风情的写照与记录。由于对文人画的过分推崇，中国传统上有点看不上以表现建筑为主的"界画"，其实袁江、袁耀、仇英、蓝瑛等的山水建筑画就是"中国式的建筑幻想画"，其环境意境、空间层次、虚实对比、于山水林木的结合等，颇能给习建筑者以启发。

建筑意与画意，意境与艺境的统一。建筑是科学，也是艺术，包括美的结构造型与环境的创造，梁思成先生称之为体形环境，因为自然界万物是有体有形的交响乐，对人居环境美的欣赏、意境的追求、场所（place，建筑术语）的创造，可作为人居环境艺术的核心方面。无论建筑设计还是城市规划与园林经营，都需要"立意"，讲求意境之酝酿与创造，讲求"艺境"之高低与文野。前人云"境生象外"，要追求"象外之象""景外之景"，而"象外之象""景外之景"不是凭空而来的，需通过观察体验，发掘蕴藏在大自然、大社会的文学情调、诗情画意加以塑造的。在这里有形之景与无形之境是统一的，建筑、绘画、雕刻、书法以至文学、工艺美术的追求是统一的。明乎此，

美术、雕刻、建筑、园林，大至城市规划、区域文化，美学的思考与追求和而不同，但它们是统一的。

人工建筑与自然建筑之交融。我对建筑专业有了较多的学习和实践后，更意识到建筑师的建筑观不能局限于单幢房屋，而应以更为开阔、更为宏观的视野，广义地理解建筑。建筑师面对的是人和自然，因此建筑的世界当以"人工建筑"（architecture of man，如房屋、街道、村镇等，无一不是建筑）为本，与"自然之建筑"（architecture of nature，树木、山川等一切自然环境的世界）为依归，融为一体。在此，"建筑"二字已非一般房子的含义，应是广义的建筑，这两者是如此的密不可分，可通称为"人居环境"。建筑师的终生追求，不仅要深入人居环境科学，还需对人居环境艺术，对蕴藏其内的艺术的规律，做力所能及的较为全面的涉猎与追求，予以整体的创造。因此，绘画以及全面的艺术修养的提高，就至为重要。

20世纪以来绘画、雕塑与建筑互为影响，创新无限，例如包豪斯的出现，不只是新建筑学派的兴起，建筑教育的变革，而且是现代文化思想、绘画、雕刻、工艺美术、视觉艺术一系列新追求的综合现象之一。荷兰海牙博物馆收藏了一套蒙德里安（P. Mondrian）的画，可以看出它是如何从自然风景逐步演化为几何图案，后来又如何影响建筑的构图的。同样，建筑的艺术亦每每影响绘画与雕塑的造型。今天科学与艺术的结合前途更加广阔无垠。

人类社会追求的就是要让全社会有良好的与自然相和谐的人居环境，让人们诗意般、画意般地栖居在大地上。这是一个建筑师的情怀。我们这个星球的内容、色彩、情趣都要比我们常眼所见的丰富千万倍，设计者各自如能放开眼界观察自然，通过绘画及其他艺术，多一些文化修养，以谨慎的态度对待专业，就能少一些粗劣与平庸，我们的生存环境可能要宜人得多。例如中国的园林艺术就是从大自然中移天缩地妙造而成的，从南宋的应试画题起，用文学的语言，激发绘画意境的创造。城市中的"十景""八景"（如西湖十景、燕京八景等），堪称世界最早的主题公园，更是大自然与人间情怀的交融，经过时间的推进，以及增饰、改造、洗练而成的风景名胜留传下来，至今仍有借鉴之处。但学者不能停留于此，依样葫芦，舍本逐末，更应读万卷书，行万里路，探源求本，即将枕外山川化为胸中丘壑，创造性的纳入规划设计中。我们希望人们珍惜、保护、创造自己的艺术环境，无知、刚愎自用只会毁坏这个环境。

Comments on Paintings by Wu Liangyong

Generally speaking, architects will regard drawing practice as a part of learning architecture, namely, techniques through freehand sketch to express structure, texture, light and natural environment of building, which is extremely profound and full of interest. Just have a look at architectural drawings of Mrs. Liang Sicheng, Yang Tingbao and Tong Jun, or rough sketches of western architects (for instance, holograph manuscripts of Louise Kang, et al collected by the architecture archives of Pennsylvania University; sketches and watercolor of Le Corbusier in the centenarian exhibition at the Pompidou Center in Paris in 1987 displaying his early year travel in Italy), you will be touched by the flash aspiration and creative thinking behind moving lines and bright colors. Modern drawing tools and computer technology have made such great progress that they reach as accurate as macrophotography. Comparing with masters in the past, however, nowadays there is a tendency for architects to be weak in freehand sketch, about which I feel confused. Personally, I am not satisfied with learning of architectural expressive techniques. I hope I can strengthen my pursuit in art and culture from drawing practice. I have found that some architect-themed paintings are richly conceived and better than general building pictures. For instance, paintings depicting St Mark's Square at Venice or other famous places can be found in big museums of western countries. These pictures are not only expressions of architecture, but also records of charm. Since the invention of perspective after the Renaissance, drawings such as architectural fantasias to express architectural concept became more, for example, early copperplate etching of Piranesi in the 18th century, structure of stage setting of German classical artist Schinker (an architect, painter, sculptor, technologist and architectural educator) by combining description and imagination of architecture and landscape with the technique of game playing. In China, paintings like Riverside Scene at Qingming Festival, Landscape of Vast Expanse and Prosperous Suzhou are generally not regarded as architecture, but as the then records of urban culture and local customs. Because of high praise for paintings of literati, building picture mainly represented by architectural expression is not thought much by the Chinese tradition. As a matter of fact, paintings of landscape and building by Yuan Jiang, Yuan Yao, Qiu Ying and Lan Ying are architectural fantasias in Chinese style, whose environmental conception, space gradation, comparison and integration of mountain, river and forests can considerably enlighten architecture learners.

Concepts between architecture and painting are unified, so is artistic conception and artistic environment. Architecture is either a science or an art including beauty of structural modeling and environmental creation. Mr. Liang Sicheng called it bodily environment, because creatures in nature are like physical symphony, which can be regarded as the core of habitat environment art for appreciation of beauty, pursuit of conception, and creation of place. Architectural design, urban planning or garden operation needs artistic conception for deliberation and creation, as well as artistic environment for taste and difference. An old saying goes like this "concept obtained from things". Pursuit in "appearance beyond things" and "sight from scenes" does not derive from imagination, but is portrayed by literature from the nature and society through observation and experience. Tangible scenes and intangible conceptions are unified,

so is the pursuit of architect, painting, sculpture, calligraphy, and even literature, arts and crafts. It is understood that aesthetic perception and pursuit of fine arts, sculpture, architect, gardening, as well urban planning and regional culture are various but harmonious, and they are unified.

Architecture of man and architecture of nature is mixed. When knowing and practicing architecture more, I have become well aware that the outlook of an architect cannot be limited to a single building. He should understand architecture in a generalized way with a broader and macroscopic view. What architect faces is man and nature. Therefore, the world of architecture should center on architecture of man (houses, streets, villages and towns are architecture), based on and mixed with architecture of nature (including natural world of trees, hills and rivers). Here architecture should be the generalized buildings, not the meaning of common houses, for these two are inseparable and called habitat environment. A lifelong pursuit for an architect is not only devoted to the science of habitat environment, but also reads and seeks widely art of habitat environment and artistic law for creation as a whole. Thus it is important to improve drawing and all-round artistic accomplishment.

Since the 20th century, painting, sculpture and architect have influenced each other with creations. For example, appearance of the Bauhaus was not the emergence of a new architectural school and the reform of architectural education, but one of the serial pursuing comprehensive phenomena of modern cultural thinking, painting, sculpture, arts and crafts, and visual arts. The Hague Museum of Holland collects a series of paintings of P. Moundrian, from which natural landscapes evolve step by step into geometric patterns that have impacts on architectural compositions. The same is true for architectural arts to influence configuration of painting and sculpture. Today prospects of the combination of science with art will be brighter.

What is pursued by mankind and society is just to provide communities with nice habitat environment in harmony with nature so that people can live on poetic and picturesque land. This is the ideal of an architect. The content, color and taste on this small planet are richer thousands of times than what we see with our own eyes. If a designer can free himself, by means of painting and other kinds of arts, to observe the nature with a prudent attitude to his profession and is well cultured, then we will have fewer things in poor quality and commonplace. In this way, our survival environment may be preferable. Formed from the nature, for example, the Chinese gardening art stimulates creation of painting concept and environment by literary language from painting topics for examination since the dynasty of the South Song. Ten scenic spots or eight scenic areas (such as 10 sights around West Lake and 8 scenes in Beijing) can be considered as the earliest theme parks in the world and the blending of nature and world. As time goes, scenic areas remain because of embellishment, upgrading and improvement, whose experience can still be of use for others nowadays. However, scholars cannot follow existing examples and stop here. They have to read more and practice more for further exploration so as to learn from nature and carry out creative work for their designs. We hope that people will treasure, protect and create their own artistic environment. Innocence and obstinacy can do nothing but destroy this environment.

主编的话

人类最早的绘画应该是画在洞窟和岩石上的岩画，不管是西班牙的阿尔塔米拉，还是中国的阴山或者是其他任何地方的岩画，这些绘画都有一个共同的特征：就是造型简练、准确而生动，不只是从时间上看有历史价值，从艺术上看，更有极高的艺术欣赏价值。不单是洞窟壁画，几乎所有的原始艺术都有和壁画相同的艺术特征：简洁生动，直接感人。原始艺术没有复杂的技巧、丰富的层次，为什么能如此生动呢？我们认为最关键的就是原始人的观察力！虽然没有专业的艺术训练，但是，在狩猎生活中长期的观察活动，对各种动物的体貌特征、运动规律，可以了然于心，所以表达起来，也就不必要像我们需要模特儿或照片了。应该说，我们现代人和古人在绘画上的最根本区别是，现代人是先通过绘画训练获得表现技巧，通过直接对照描绘对象或照片来表现事物，而原始人是在长期观察动物的基础之上，对表现对象烂熟于心，凭借记忆描画对象，虽然没有多少细节，但往往表现的都是最关键的特征，所以生动、简洁而感人，这是原始艺术的价值所在。

牛顿因为观察到苹果落地而研究出万有引力定律，凭借的是敏锐地观察能力，科学家要靠观察力洞察到研究对象的特征和规律，在科学史上这样的著名例子举不胜举，在最普通的研究过程中，如果没有敏锐的观察力也是不可想象的。

世界上有两个著名的吴兴亮，一个是菌物学家吴兴亮，在热带菌物研究成绩卓著，做国家级的科研，出国家级的成果，学科翘楚，著述远播。另一个，就是我们现在看到的水彩画家的吴兴亮。吴兴亮先生首先是作为一位科学家开始他的职业生涯的，作为菌物学者，他从事的菌物分类学首先需要的是敏锐的观察力，也就是在那时他开始了对绘画的学习，像达尔文一样，他需要记录观察的对象，他对绘画的研究也就一直伴随他的科学研究，这是两个平行的体系，他同时体验着科学家的严谨和艺术家的浪漫，这两者同时需要的是投入和执着的精神，都需要敏锐的观察力，他正是把这些优秀的品质统一起来的人，所以他是把科学和艺术打通的人，在菌物分类学上有不凡的成绩，在水彩画艺术上也有深厚的造诣，这样的成就一般不会为人所理解，我们知道，不管是一位科学家，还是一位艺术家，在激烈的行业竞争中，在某一个方面能够出人头地取得突出成就已经非常不易，更何况同时在两个方面同时取得优异成就，莫非他是超人不成。

吴兴亮不是超人，他的经验最可贵、最有启发意义的是科学和艺术的基础性问题，是艺术学习和科学研究的方法问题，对于青年学生来说，研究他的绘画技艺的同时，应该同时关注他的菌物学成果，而这本画集的意义更应该被科学研究者所重视。这里面有研究方法的启示，更有研究精神的意义，也有关于科学家、艺术家人格成长和塑造的故事。

吴兴亮的水彩艺术成就、高度和造诣在这本画册里可以集中体现，他的绘画构图、造型严谨而理陆，色彩优雅而和谐，他追求画面色调的整体统一，在明度上注重对比，突出光线的视觉效果。他注重水彩画特性的表现，娴熟多变的湿画法每每是他画作的得意之处，和人们对科学家理陆的特征印象不同的是，他非常注意水彩画的激情表达，在写生中表现水色流动的张力和动感，是他刻意追求的艺术效果和境界。也许，他在水彩画的光色流动，气韵氤氲之中，体会到了天地万物的律动，体会到了菌物研究中不能表达的世界的不确定性和神秘意义。体会到了，踏遍热带雨林采集标本之外，采集的自然之气，生命之气！也许，他在水彩画中体会的激情和动感才是他人生追求的本质。这些我们不必跟他求证，我们只需要在他的画里寻求答案就够了。我想说，最重要的事情是：不管是艺术家还是科学家，寻求对生存世界的个人解答是他们的兴趣，也是他们的使命，更是他们追求的目标，科学和艺术，在表面的不同之外，更重要的是相同之处。这方面，吴兴亮用他的行动实现了，他的视野、他的方法、他的境界，对我们艺术青年有更积极的学习和研究意义。

于清华大学
2011年10月28日

Words from Chief Editor

The earliest painting of mankind is rock painting in caves or on rocks, no matter they are in Altamira of Spain, in Yinshan of China or in any other places. These paintings have common characteristics – simple, accurate and vivid. Judging from time, these paintings have historical value. In terms of art, they have higher value for appreciation. Almost every kind of original art, not limited to the cave painting, has the same artistic characteristics: moving people directly in a concise but amazing way. How can original art, without complicated skill and rich level, become so lovely? The most important point is, we think, the observation of primitive man. Though they did not have professional art training, they had known all about appearance features and movement inclinations of different animals, owing to their observation for quite a long time during their hunting life. When expressed, therefore, they did not need at all models or photos like us. It should be pointed out, the fundamental difference in painting between modern man and primitive man is that modern man gains skills through training to express things via direct comparison with objects or images, while primitive man depicted their objects by memory based on long-timed observation of animals. Without details, their expressions were the most critical. That is the reason why their paintings turn out to be vivid, simple and moving. That lies the vale of original art.

Depending on his ability of sensitive observation, Newton studied law of universal gravitation when seeing fallen apples. A scientist relies on his observation to understand properties and laws of his research object. Such well-known examples are numerous in the history of science. It is hard to image that there is no sensitive insight even for the most common study.

Mr. Wu Xingliang is both a mycologist and a painter. As a mycologist, Mr. Wu studies tropical fungi with outstanding research accomplishments. His projects belong to national-level. As a painter, Mr. Wu began his career as a scientist at first. He worked as a mycologist to engage in classification of fungi which necessarily needed sensitive observation. It was at that time that he started to learn to paint. Like Darwin, he needed to record his observed objects. His study on painting goes with his scientific research. This is a paralleled system which enables him to become a strict scientist and a romantic artist. He needs input and pursuit to play these two roles, for both need sensitive observation. He is just a man to unify the good qualities. As a result, he is successful both in science and art, with extraordinary findings in classification of mycosystema and profound attainments in water-color painting. Generally, people cannot understand such achievements. As we know, it is not easy for a man in the intense competition to get prominent in one field, no matter he is a scientist or an artist. Nevertheless, Mr. Wu is excellent in both of these aspects. Is he a superman?

Mr. Wu Xingliang is not a superman. Concerning the foundation of science, his most valuable and most instructive experience is about methods of artistic study and scientific research. When young students study his painting skills, they should pay attention to his mycological achievements. The significance of this picture album should be taken seriously by scientific researchers. In this book, one cannot merely find researching methods and spirit, but stories of personality development and shaping of a scientist and an artist as well.

In a concentrated way, this picture album reflects Mr. Wu's achievement, height and attainment in water-color art. His paintings have

serious and reasonable structure, elegant and harmonious colors. What he looks for is a unified tone of the entire picture and the contrast in brightness to gain a visual effect of light. He is proud of his skilled and changeable wet-painting method, because Mr. Wu attaches importance to expressing water-color features. Different from the scientist's rationality, he has passionate expression in his water-color paintings. Running water showing tension and dynamic in his sketches is just the visual effect and state he deliberately seeks. Perhaps, he experiences the rhythm of nature in light color flow and neon magic emanation whose uncertainty and mystery cannot be expressed in the study of mycosystema. He experiences the spirit of nature and the truth of life in addition to sample collection in tropical rainforest. Maybe, passion and dynamic he feels in water-color is just the life nature he is in pursuit. It is unnecessary for us to prove it from him. We only need to get the answer from his paintings. I'd like to say that the most important thing is to search personal solutions of this survival world, no matter they are scientist or artist, which is their mission and goal. Scientist and artist have common point apart from their superficial difference. Mr. Wu Xingliang has realized this respect by his action. His vision, method and ideal have been proactive to the study and research for art youth.

<div align="right">

Gao Dong
in Tsinghua University
October 28, 2011

</div>

目　录

序
吴良镛论绘画
主编的话

01　清华荷塘
02　花的静物写生
03　晨曦
04　归
05　婺源思溪
06　婺源巷子
07　憩
08　青岛小景
09　青岛红房子
10　北欧风光
11　船
12　丁香
13　牡丹花
14　白玉兰
15　石膏与铜壶
16　紫玉兰
17　丁香花与石膏像
18　瓶花
19　绍兴
20　泊
21　避风港
22　罐子与干果
23　迎春花与玉兰
24　寨子
25　树
26　水乡
27　北京龙泉寺
28　婺源旧房子
29　绍兴柯桥
30　婺源村口
31　小河边
32　贵州石板房
33　婺源晓起
34　雨后越南下龙湾
35　秋溪
36　海南岛三亚礁石之一
37　海南岛三亚礁石之二
38　小渔船
39　婺源小李坑
40　小树林
41　屯堡巷子
42　婺源斜阳
43　溪沟
44　芒果与绿苹果
45　水果和罐的静物写生
46　有蓝花布的静物
47　罐子与水果的静物写生
48　青岛建筑
49　热带植物
50　陶罐与水果
51　铜壶与罐子
52　深山里的溪沟
53　荷花
54　西瓜与啤酒瓶
55　芒果与苹果
56　铜火锅
57　衬布
58　婺源小景之一
59　婺源小景之二
60　巷子
61　河岸
62　陶罐与红衬布
64　水彩静物速写
66　热带水果
68　寓理于画　臻于至善
　　——记吴兴亮教授的水彩艺术

CONTENTS

Preface
Comments on Paintings by Wu Liangyong
Words from Chief Editor

01 A Lotus Pond in Tsinghua University
02 Still life with Flowers
03 Morning Light
04 Return
05 The Sixi Stream of Wuyuan County
06 The Lane of Wuyuan County
07 Having a Rest
08 A Scene in Qingdao City
09 Red-roofed Buildings in Qingdao City
10 Scenery in Northern Europe
11 Boats
12 Clove
13 Peony
14 Magnolia
15 Plaster and Bronze Pot
16 Magnolia Liliflora
17 Clove and Plaster Busts
18 Flowers in Vase
19 Shaoxing City
20 Berth
21 A Harbor
22 Jar and Nuts
23 Winter Jasmine and Magnolia
24 A Village
25 Trees
26 Riverside Scenery
27 The Longquan Temple of Beijing
28 Old Buildings in Wuyuan County
29 Keqiao Bridge in Shaoxing City
30 A Village Entrance of Wuyuan County
31 On the Creek
32 The Stone House in Guizhou Province
33 Morning Scene of Wuyuan County
34 Halongbay after Rain
35 A Brook in Autumn
36 Reefs of Sanyan in Hainan Province (1)
37 Reefs of Sanyan in Hainan Province (2)
38 Fishing Boats
39 The Xiaolikeng Pit in Wuyuan County
40 A Grove
41 The Lane in a Tunpu Village
42 The Setting Sun of Wuyuan County
43 Rivulet
44 Mango and Green Apple
45 Still life with Fruit and jar
46 Still Life on Orchid Cloth
47 Still life with Jar and Fruits
48 Architecture in Qingdao City
49 Tropical Plants
50 Pottery and Fruits
51 Copper Kettles and Mugs
52 A Torrential Stream in High Mountain
53 Lotus Flowers
54 Watermelons and Beer Bottles
55 Mangos and Apples
56 A Copper Hotpot
57 Lining Cloth
58 Scene of Wuyuan County (1)
59 Scene of Wuyuan County (2)
60 An Alley
61 River Bank
62 Pottery and Red Lining Cloth
64 Sketch of Still Life in Watercolor
66 Tropical Fruits

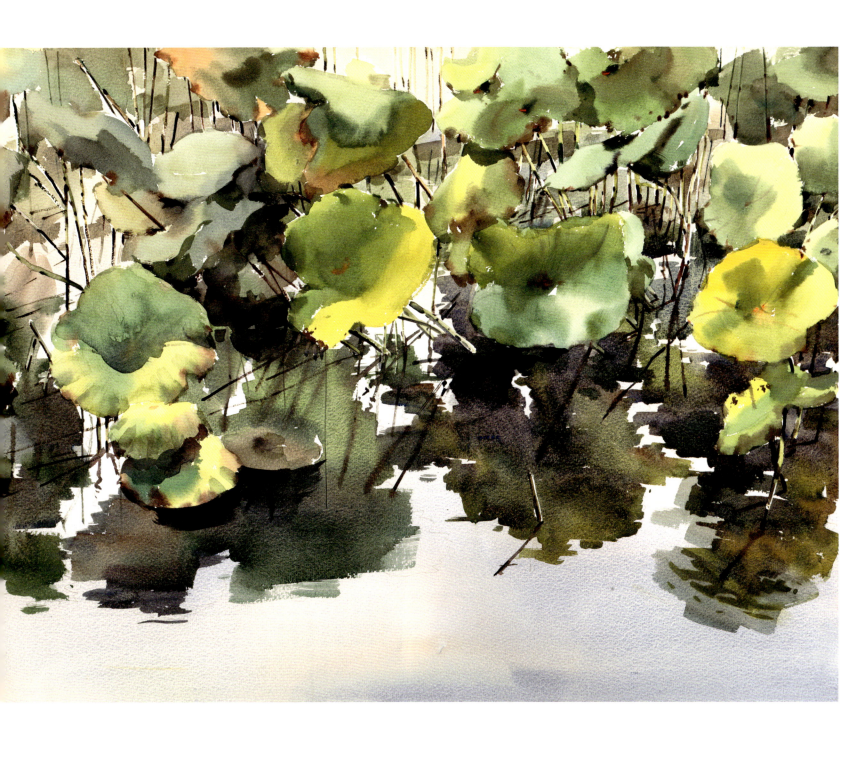

清华荷塘　38cm×53cm　2009年　‖　A Lotus Pond in Tsinghua University　38cm×53cm　2009

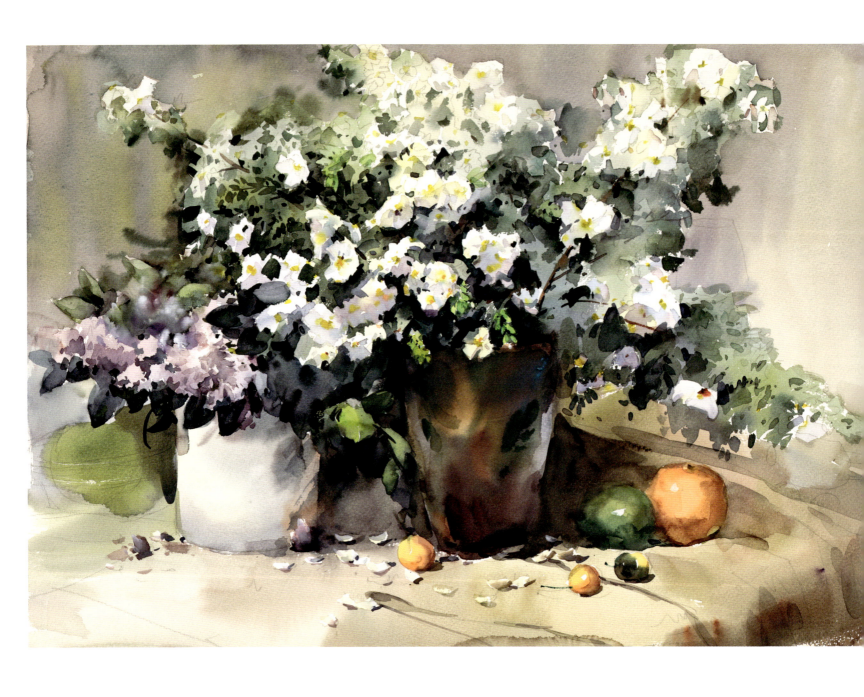

∧ 花的静物写生　56cm×75cm　2010年　‖　Still life with Flowers　56cm×75cm　2010

＞ 晨曦　53cm×38cm　2011年　‖　Morning Light　53cm×38cm　2011

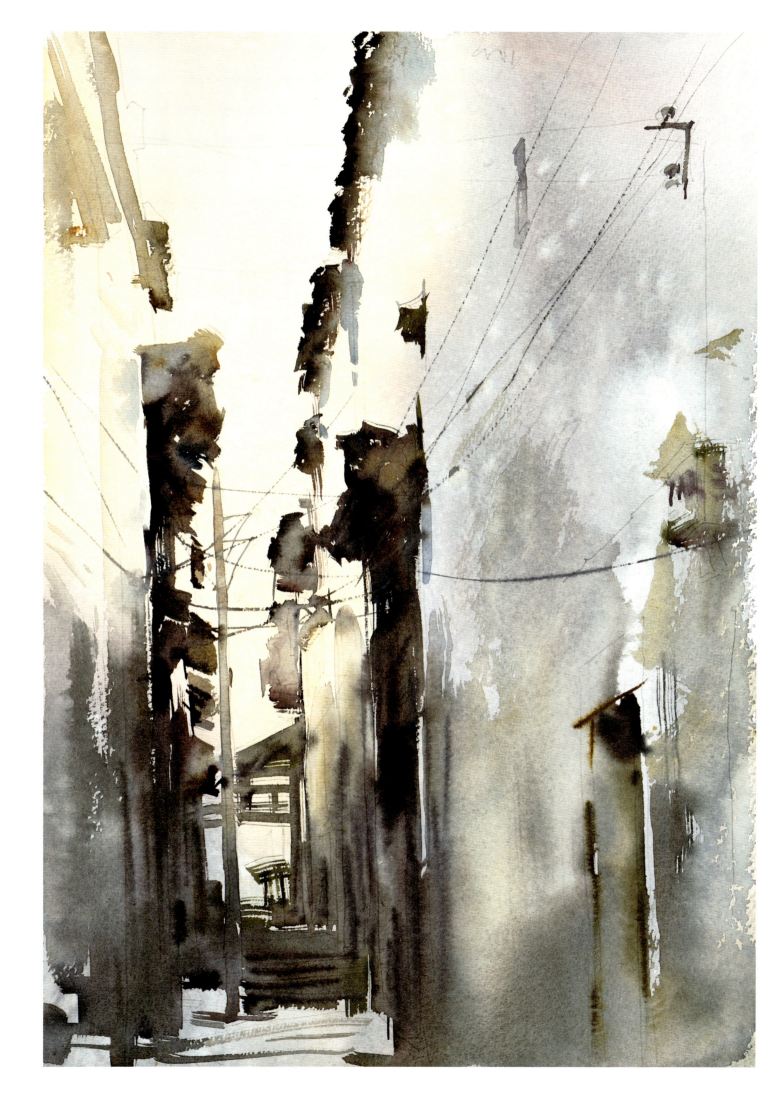

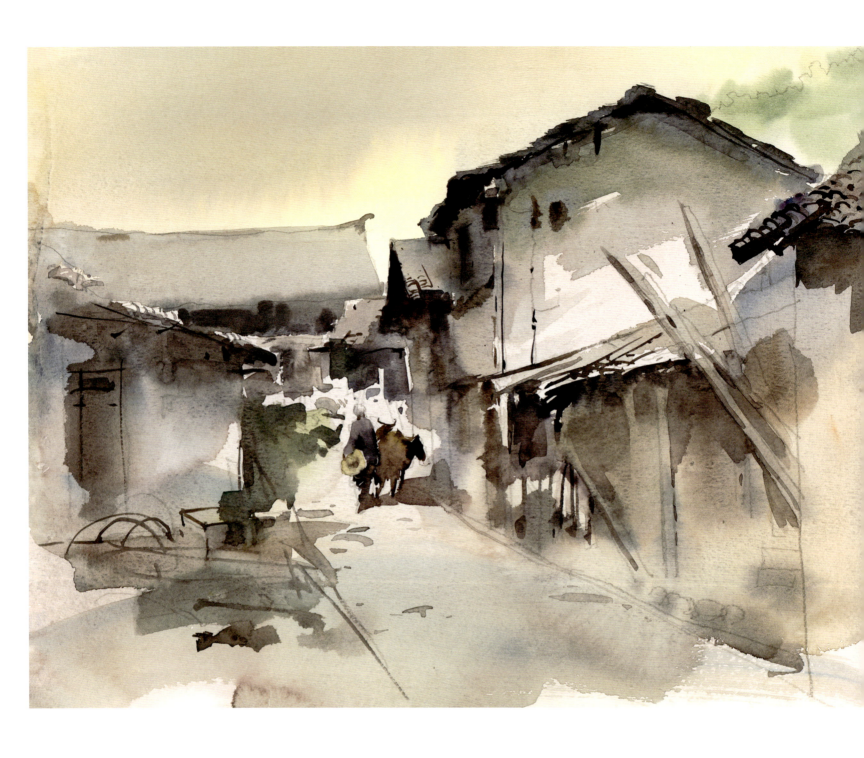

∧ 归 38cm×53cm 2009年 ‖ Return 38cm×53cm 2009

﹥ 婺源思溪 58cm×38cm 2011年 ‖ The Sixi Stream of Wuyuan County 58cm×38cm 2011

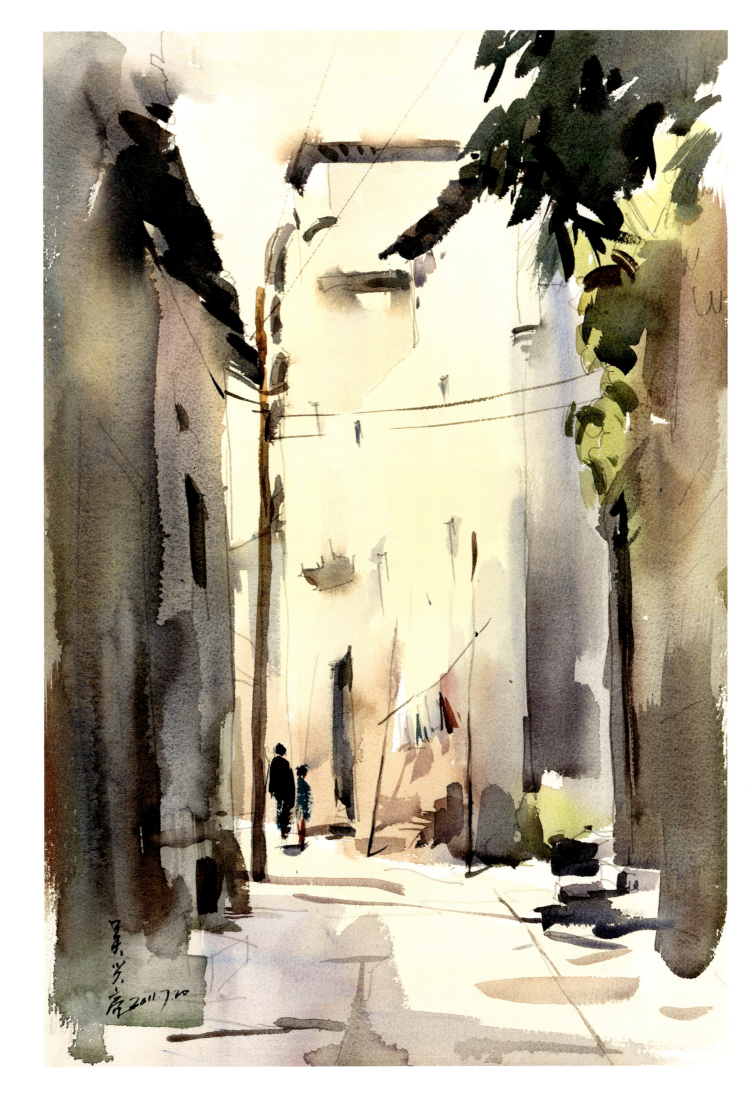

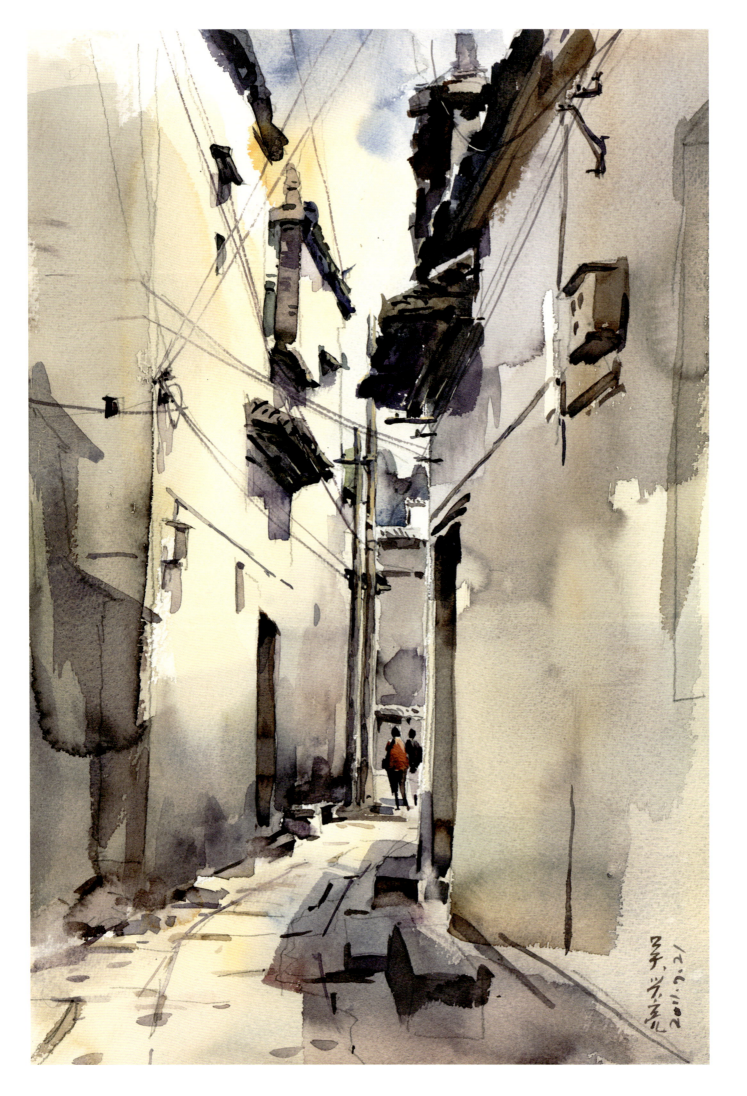

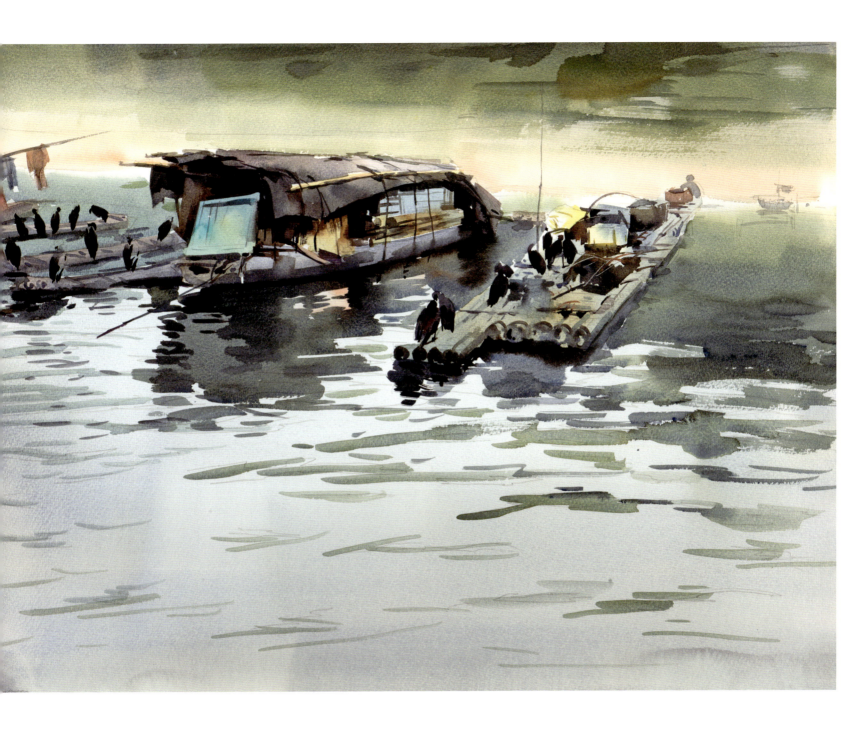

∧ 憩　53cm×75cm　2009年 ‖ Having a Rest　53cm×75cm　2009

< 婺源巷子　53cm×38cm　2011年 ‖ The Lane of Wuyuan County　53cm×38cm　2011

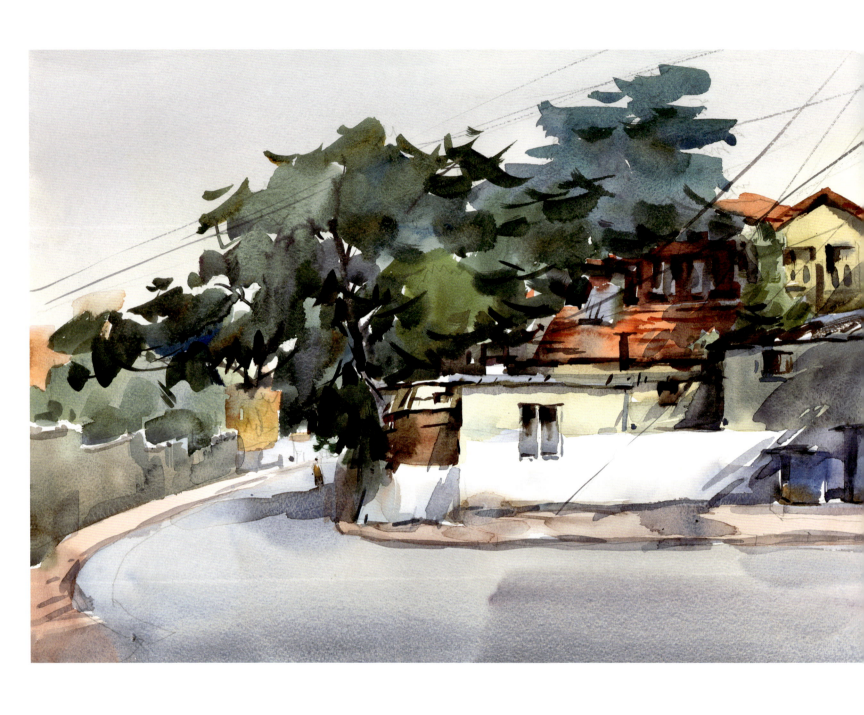

青岛小景　38cm×53cm　2010年　‖　A Scene in Qingdao City　38cm×53cm　2010

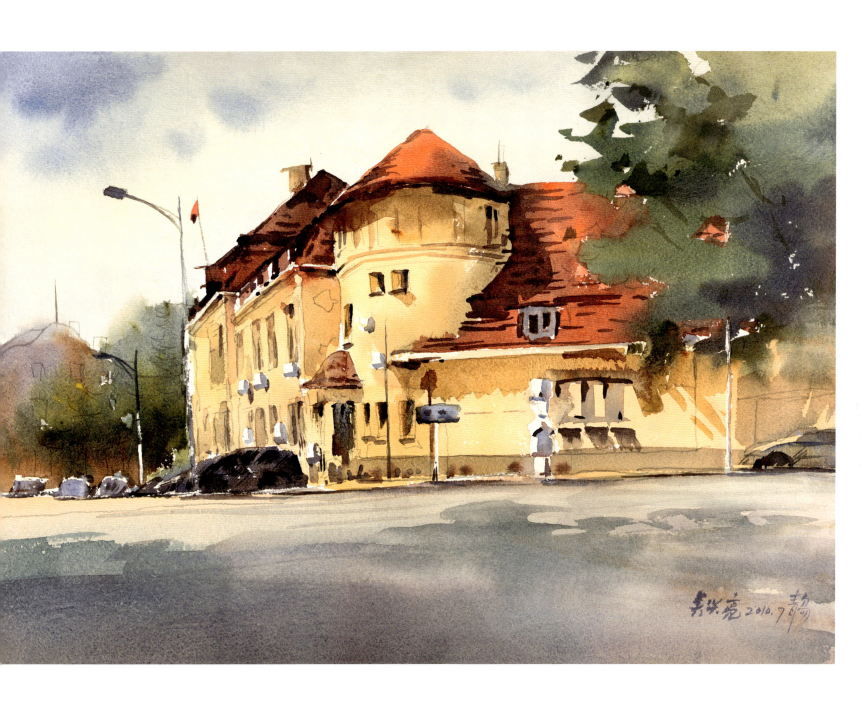

青岛红房子　38.2cm×26.4cm　2010年　‖　Red-roofed Buildings in Qingdao City　38.2cm×26.4cm　2010

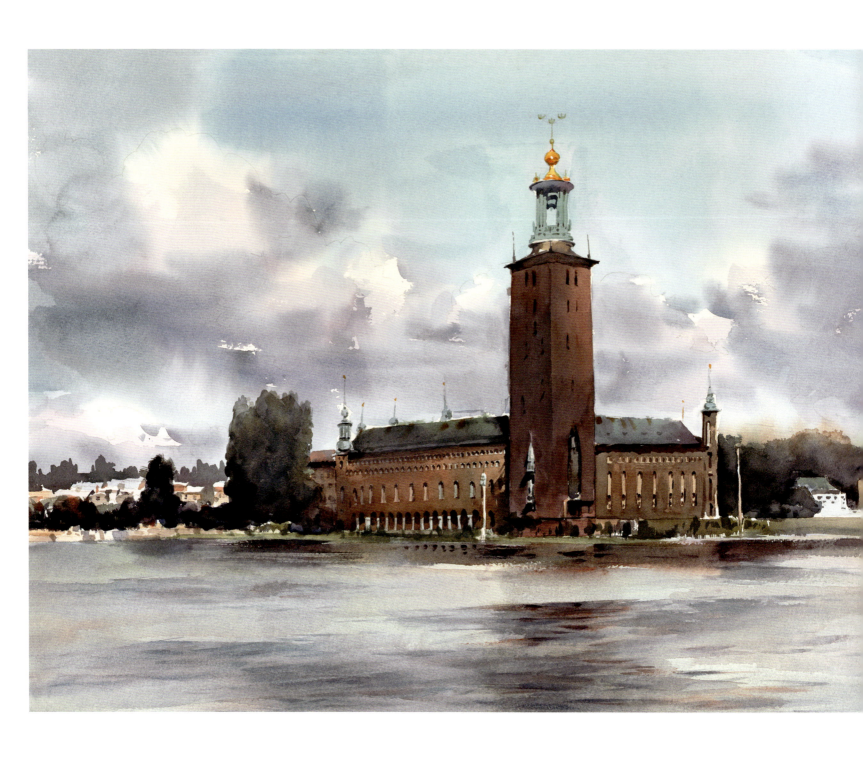

北欧风光　58cm×73cm　2009年　‖　Scenery in Northern Europe　58cm×73cm　2009

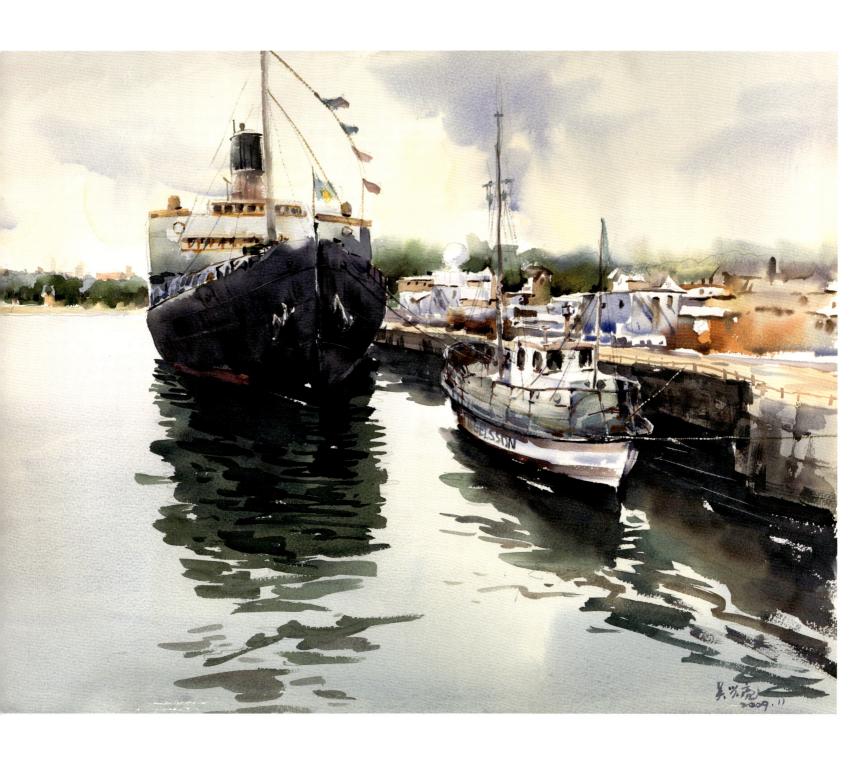

船　58cm×73cm　2009年　‖　Boats　58cm×73cm　2009

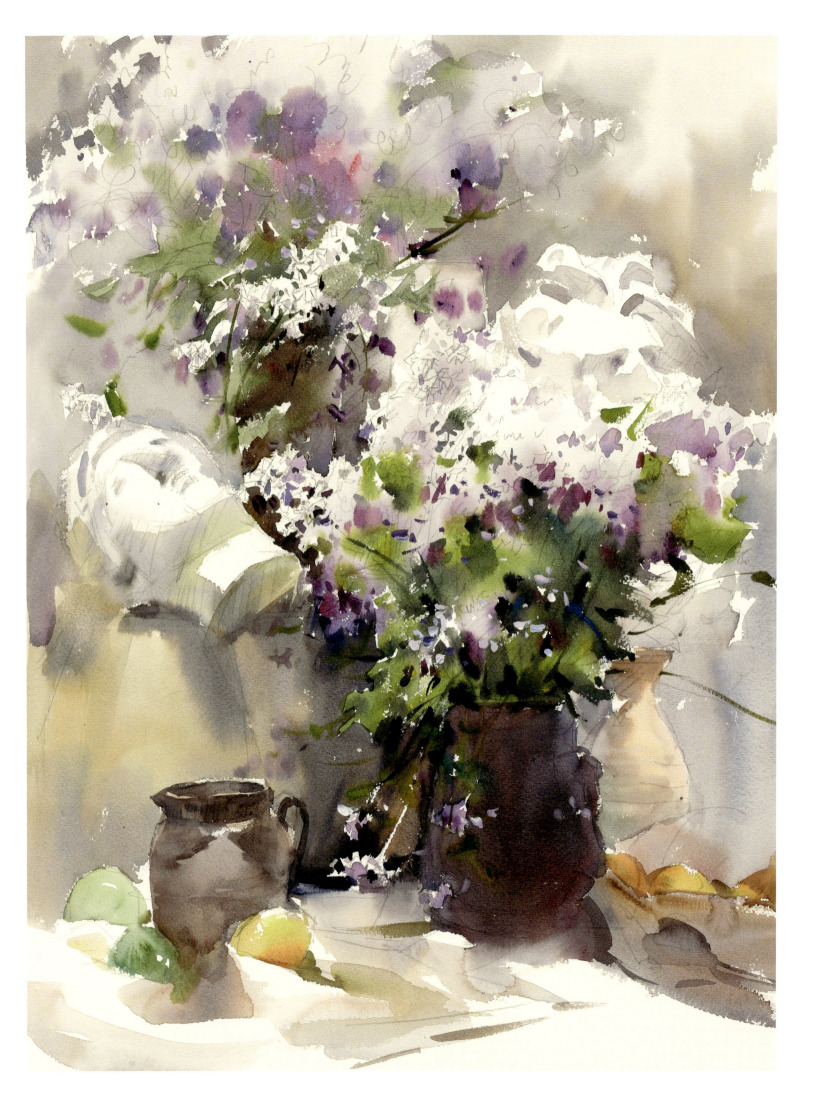

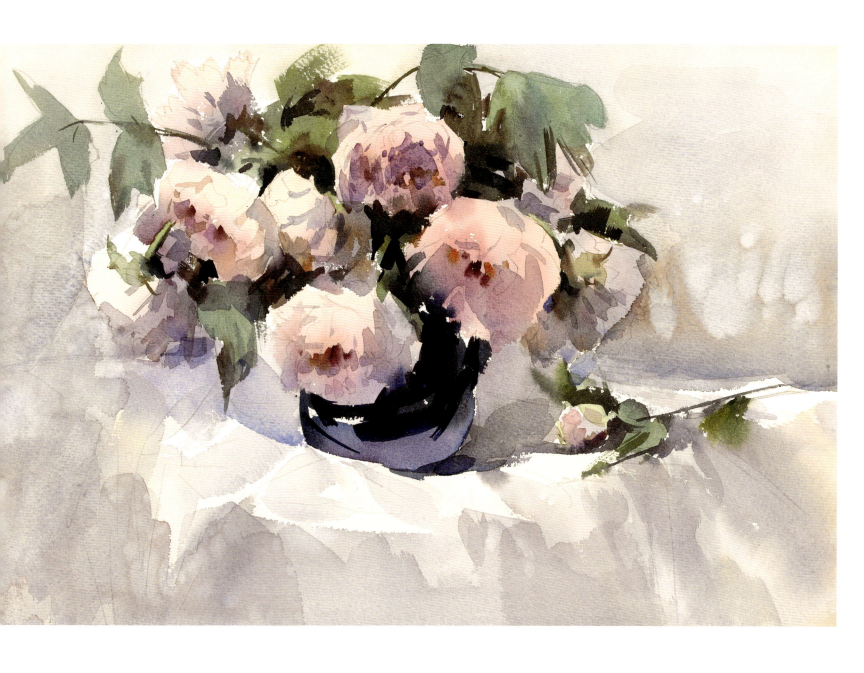

∧ 牡丹花 58cm×73cm 2011年 ‖ Peony 58cm×73cm 2011

< 丁香 58cm×38cm 2010年 ‖ Clove 58cm×38cm 2010

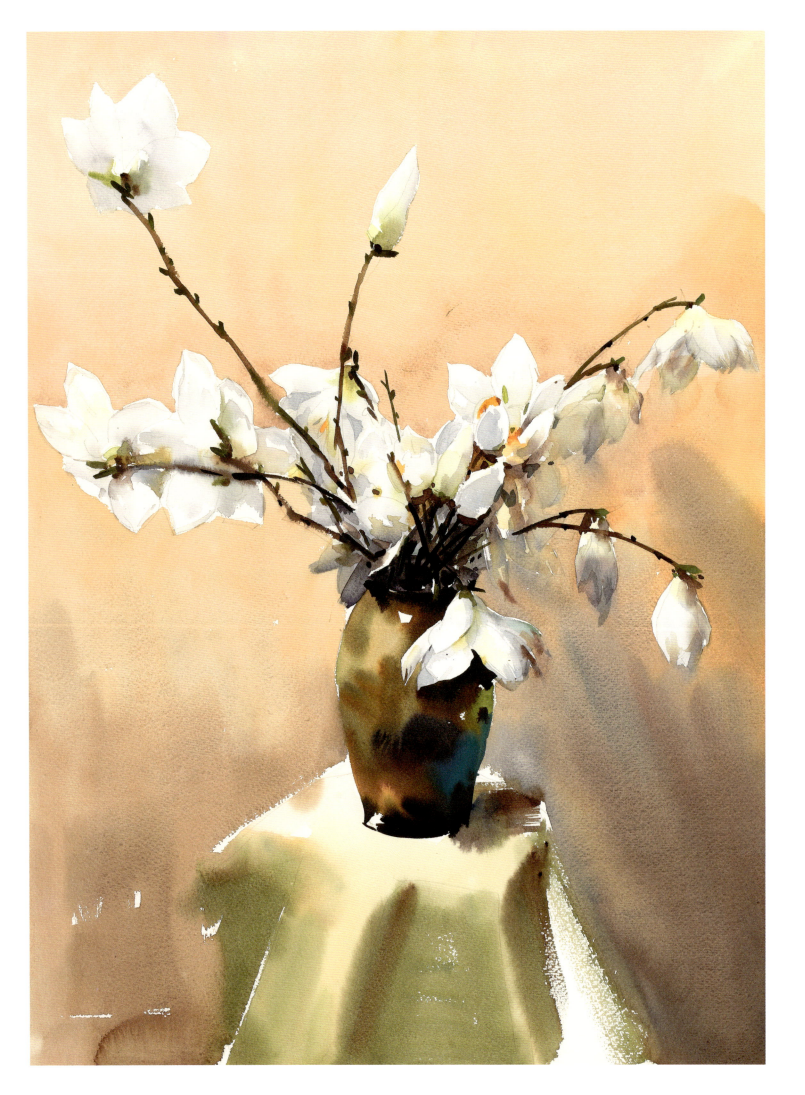

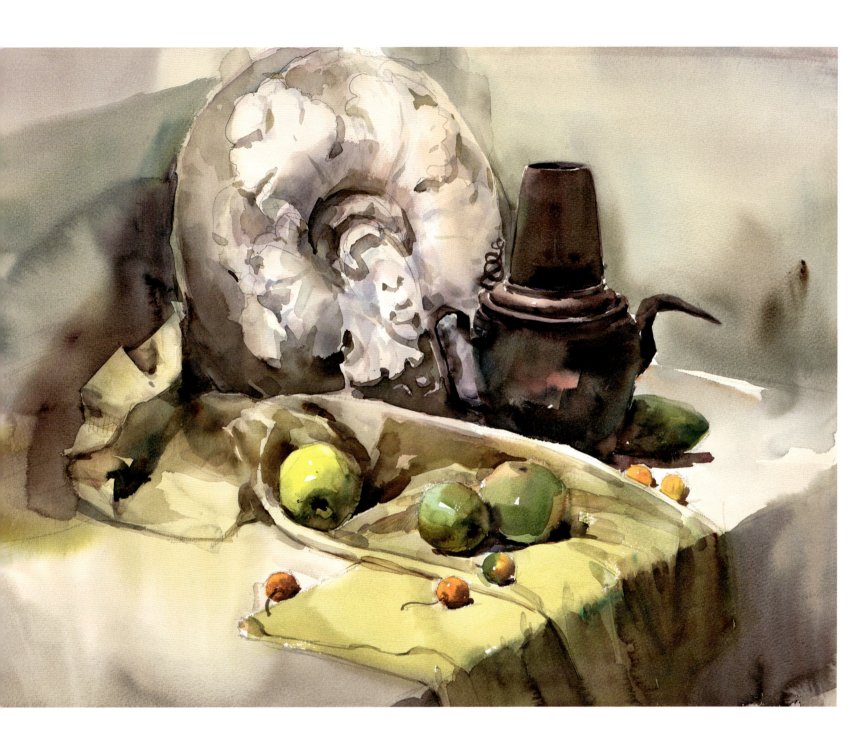

∧ 石膏和铜壶　54cm×73cm　2009年　‖　Plaster and Bronze Pot　54cm×73cm　2009

< 白玉兰　75cm×57cm　2010年　‖　Magnolia　75cm×57cm　2010

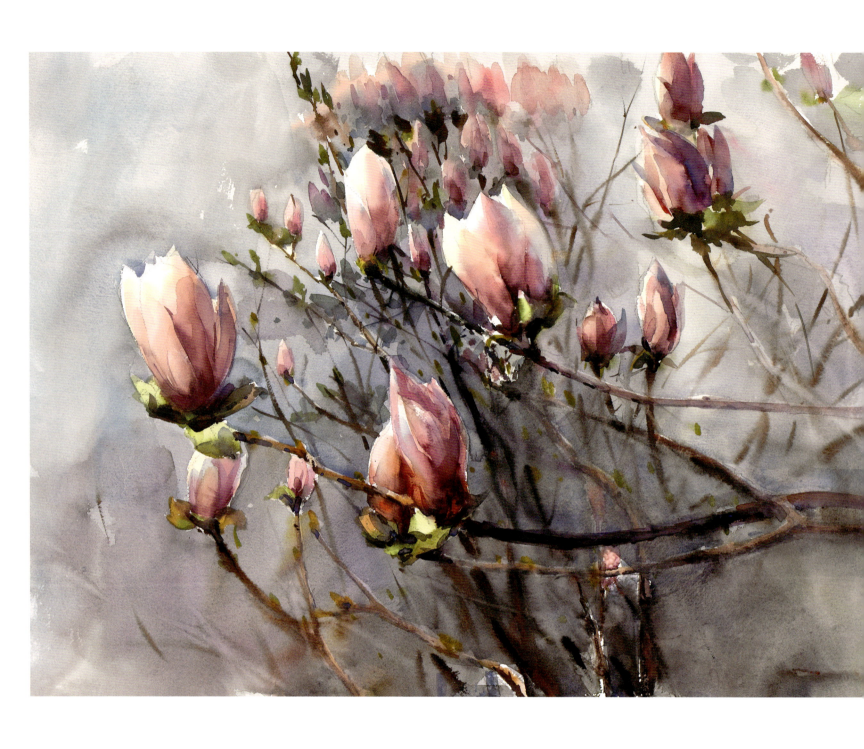

紫玉兰　58cm×73cm　2010年　‖　Magnolia Liliflora　58cm×73cm　2010

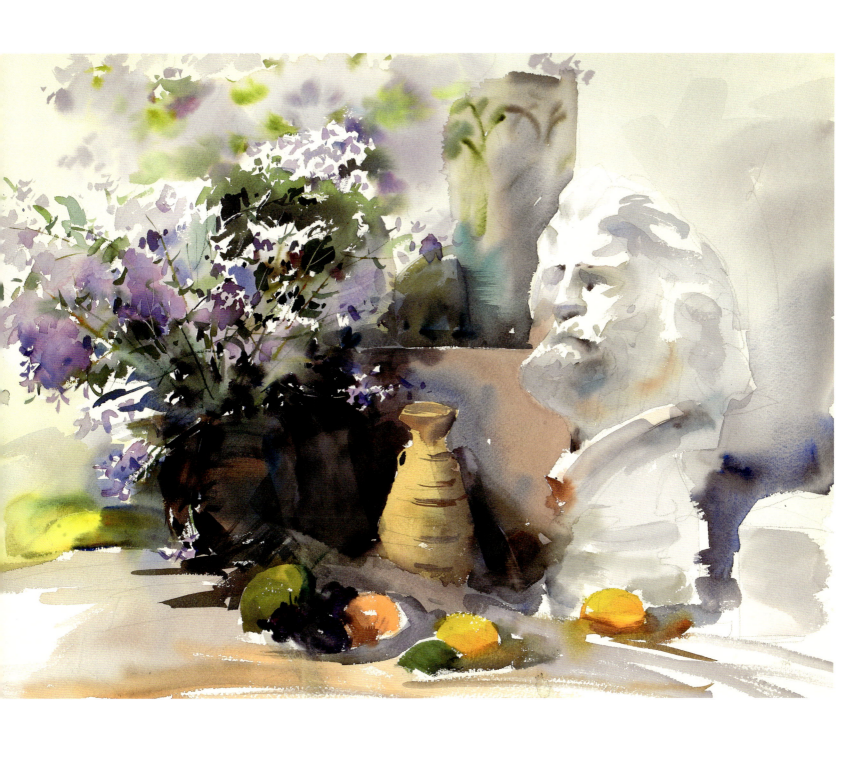

丁香花与石膏像　53cm×73cm　2010年　‖　Clove and Plaster Busts　53cm×73cm　2010

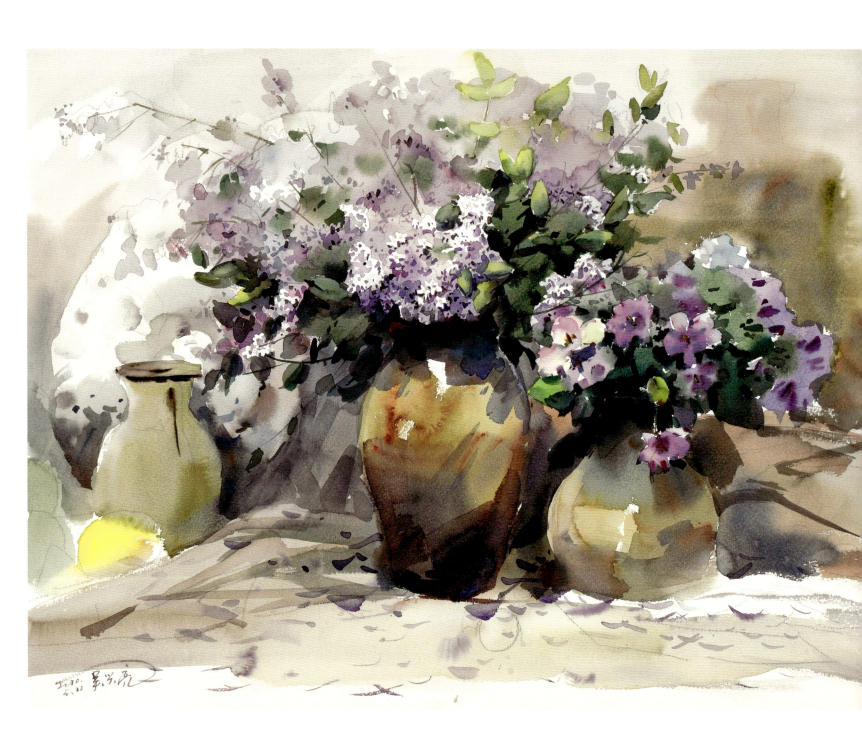

∧ 瓶花　54cm×73cm　2010年　‖　Flowers in Vase　54cm×73cm　2010

> 绍兴　73cm×54cm　2009年　‖　Shaoxing City　73cm×54cm　2009

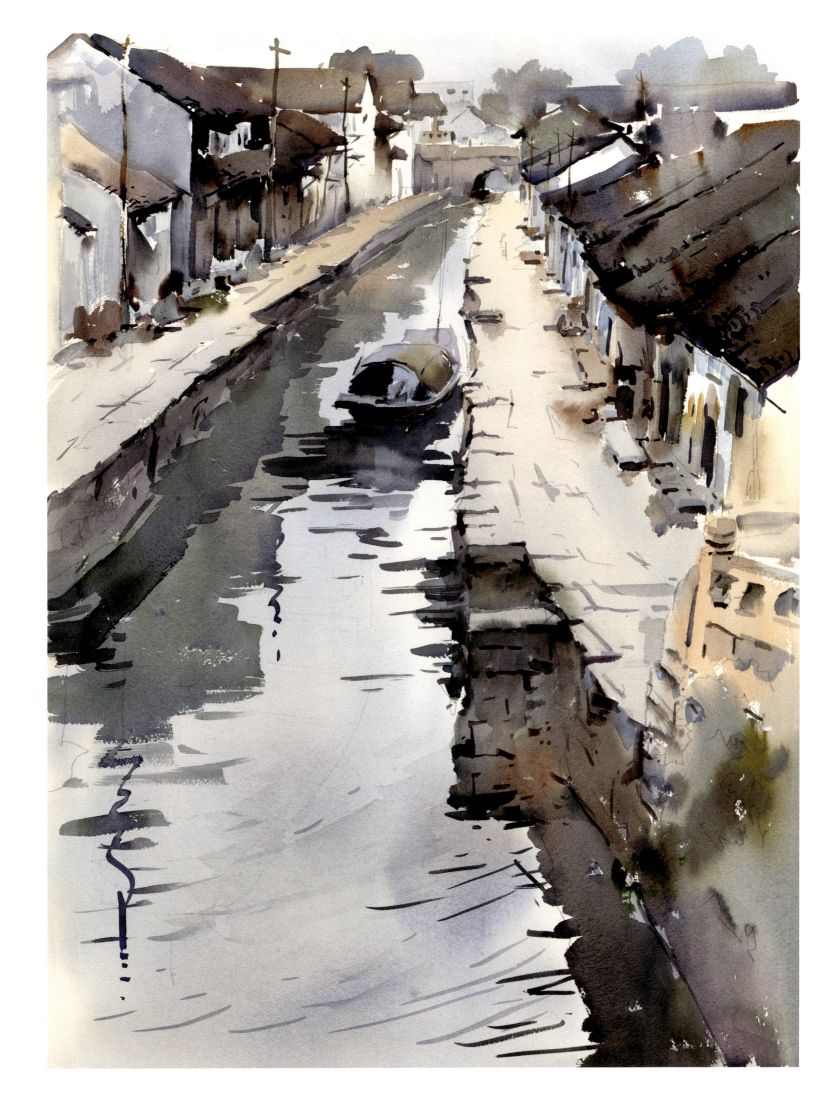

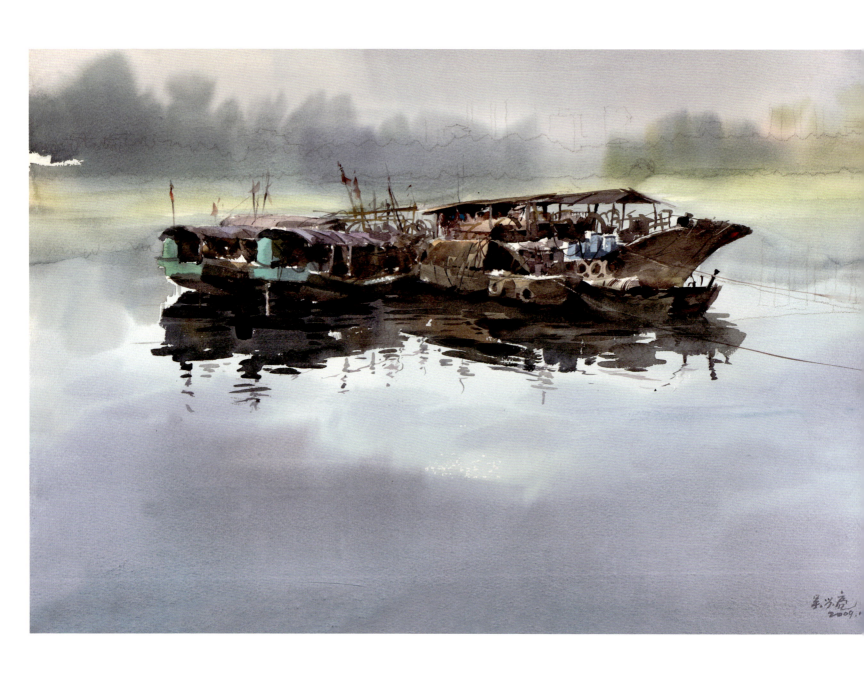

泊 53cm×75cm 2010年 ‖ Berth 53cm×75cm 2010

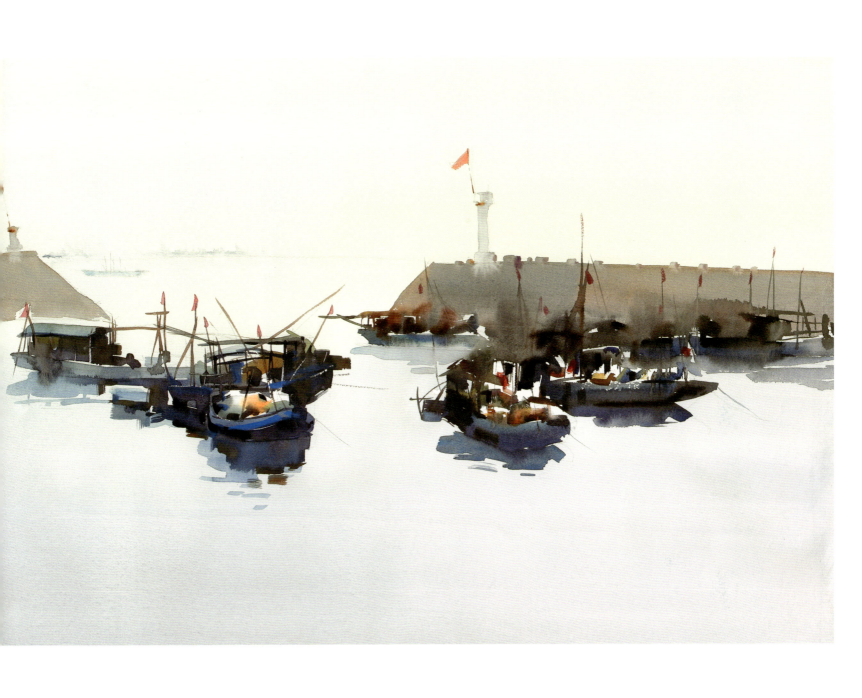

避风港　53cm×75cm　2010年　‖　A Harbor　53cm×75cm　2010

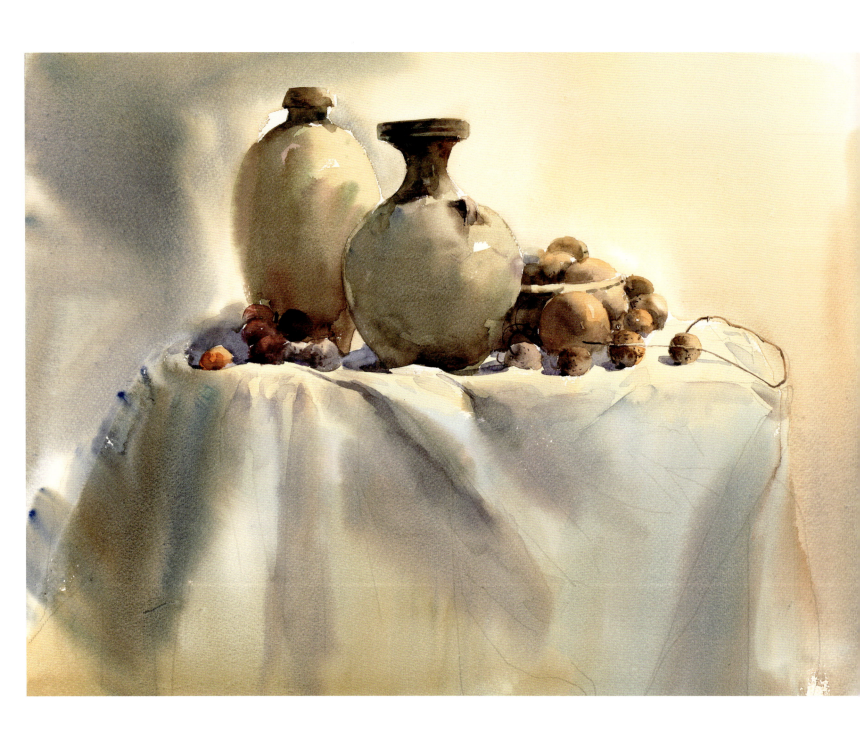

罐子与干果　53cm×73cm　2010年　‖　Jar and Nuts　53cm×73cm　2010

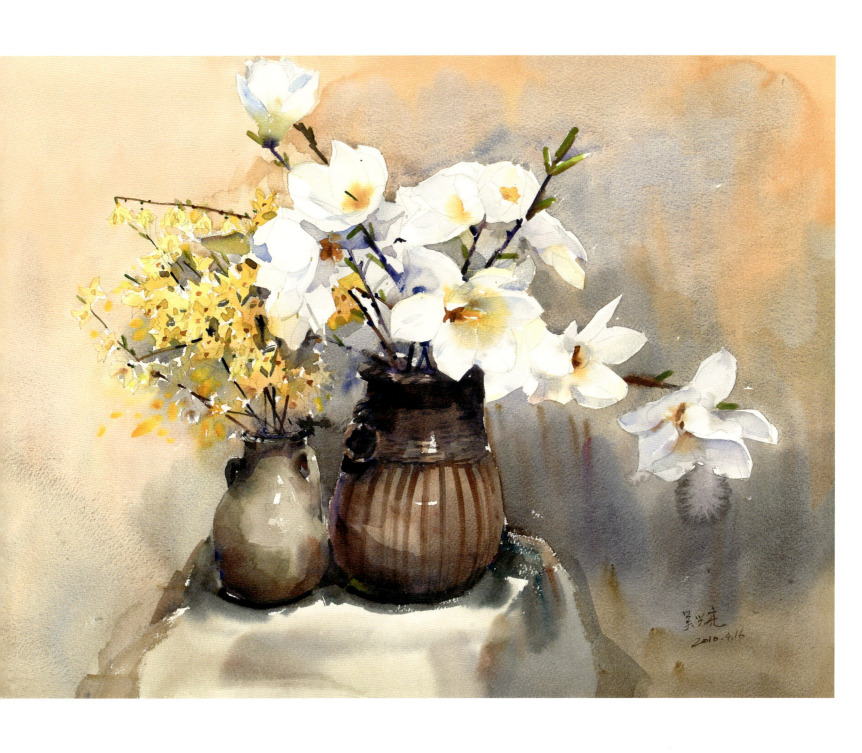

迎春花与玉兰　58cm×73cm　2010年 ‖ Winter Jasmine and Magnolia　58cm×73cm　2010

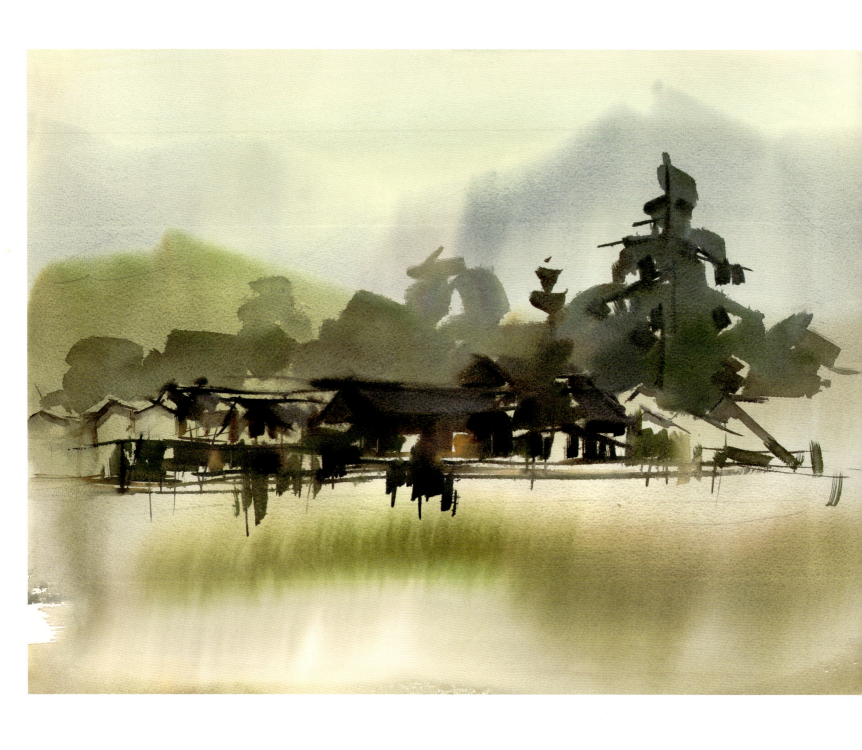

∧　寨子　53cm×75cm　2009年　‖　A Village　53cm×75cm　2009

＞　树　75cm×53cm　2009年　‖　Trees　75cm×53cm　2009

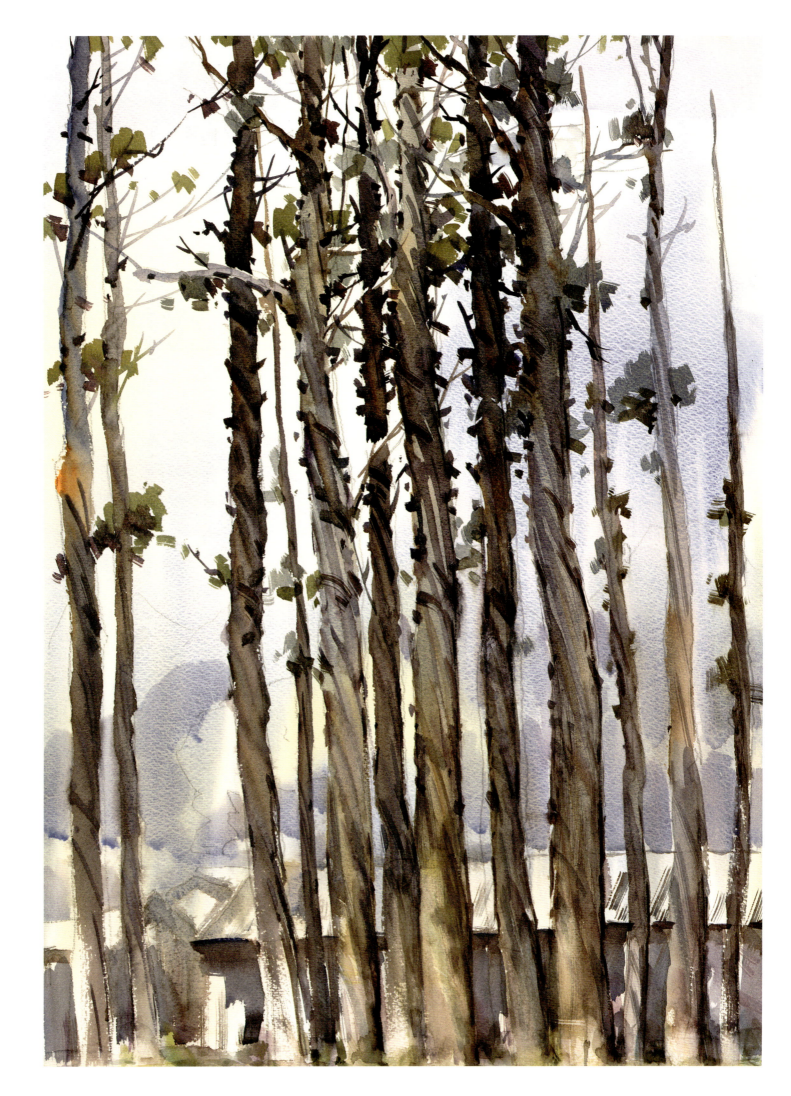

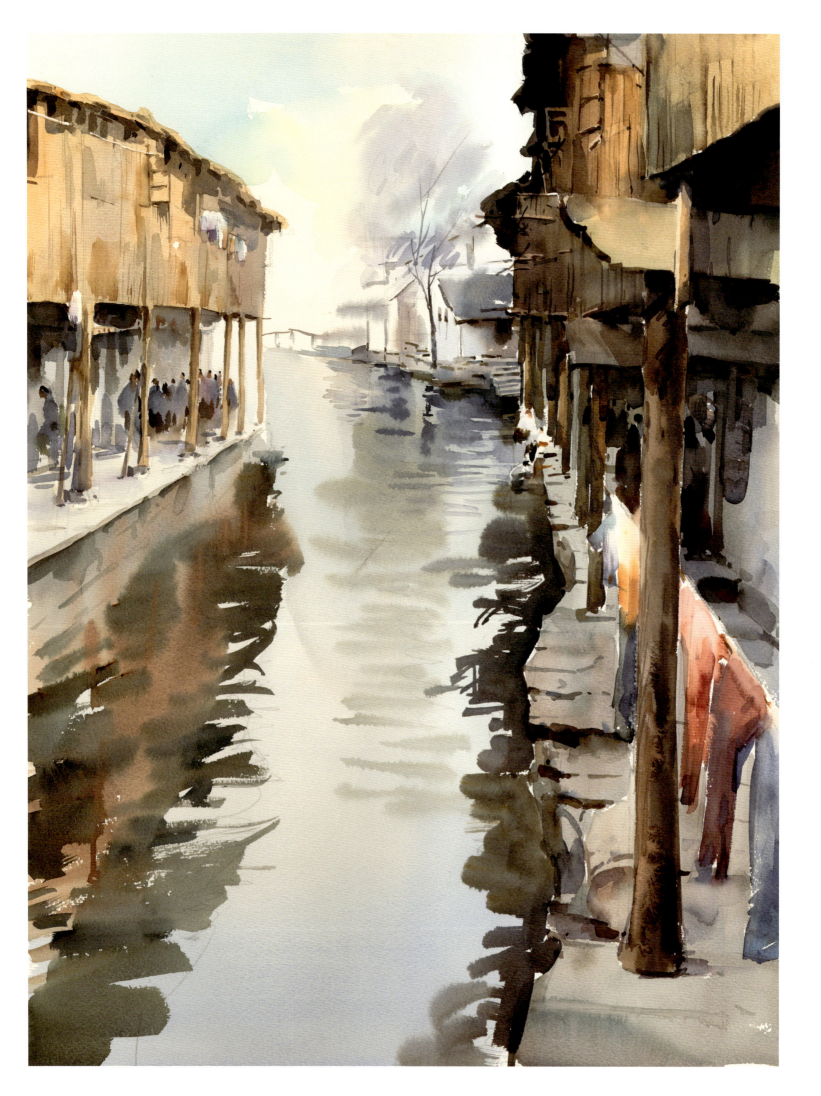

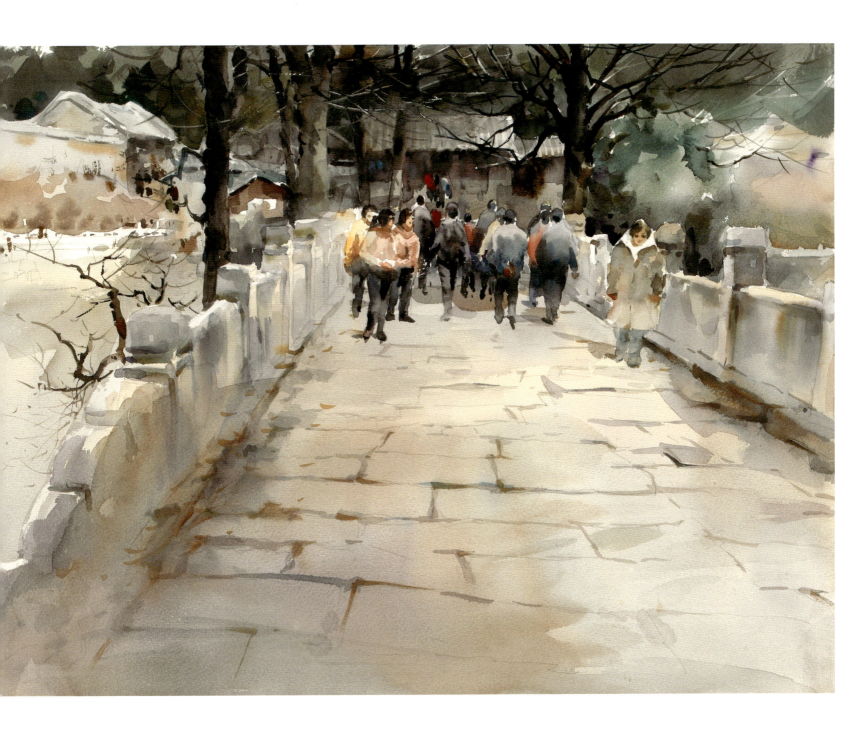

∧ 北京龙泉寺　53cm×75cm　2009年　‖　The Longquan Temple of Beijing　53cm×75cm　2009

< 水乡　73cm×58cm　2009年　‖　Riverside Scenery　73cm×58cm　2009

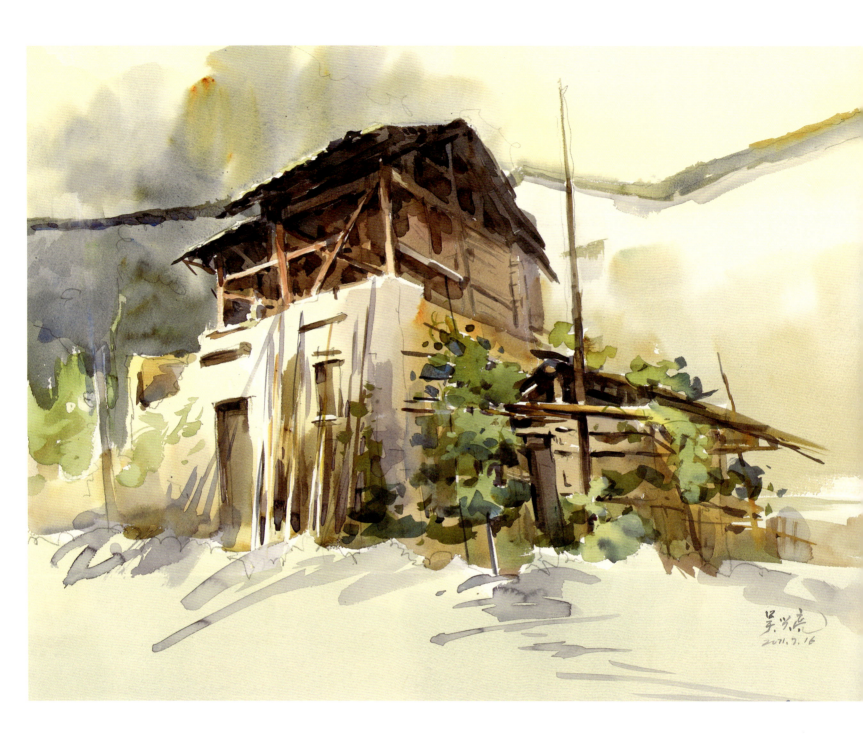

∧ 婺源旧房子　53cm×75cm　2011年　‖　Old Buildings in Wuyuan County　53cm×75cm　2011

> 绍兴柯桥　75cm×53cm　2008年　‖　Keqiao Bridge in Shaoxing City　75cm×53cm　2008

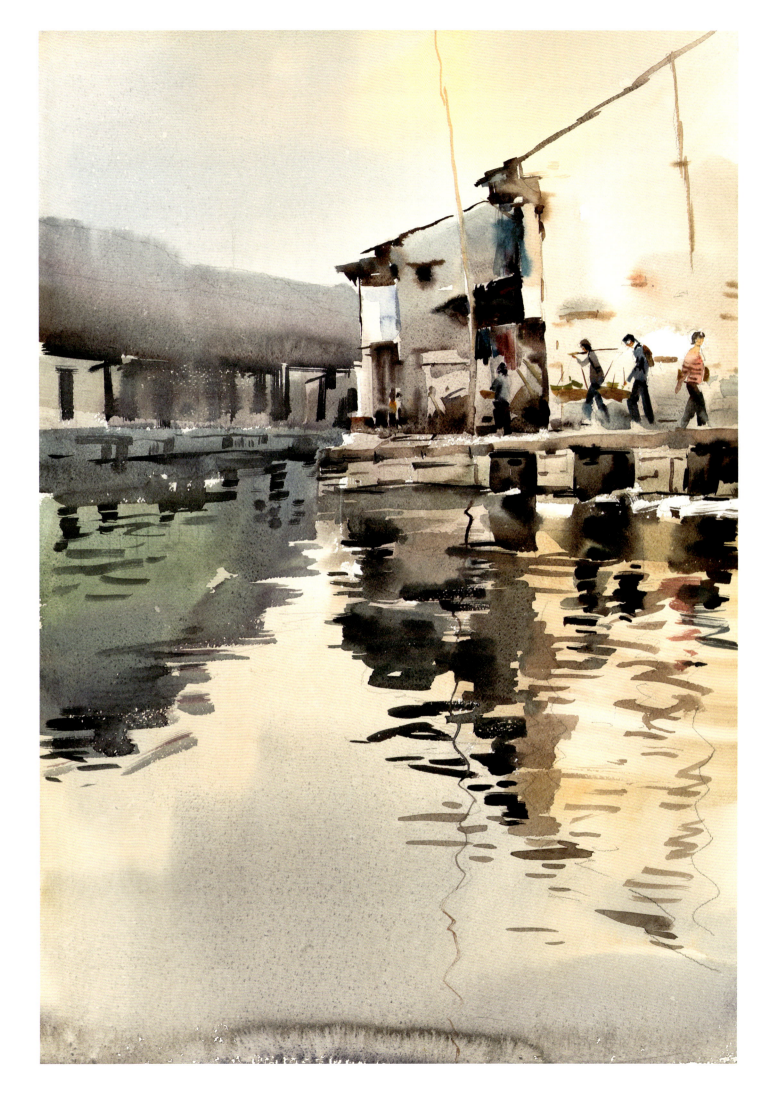

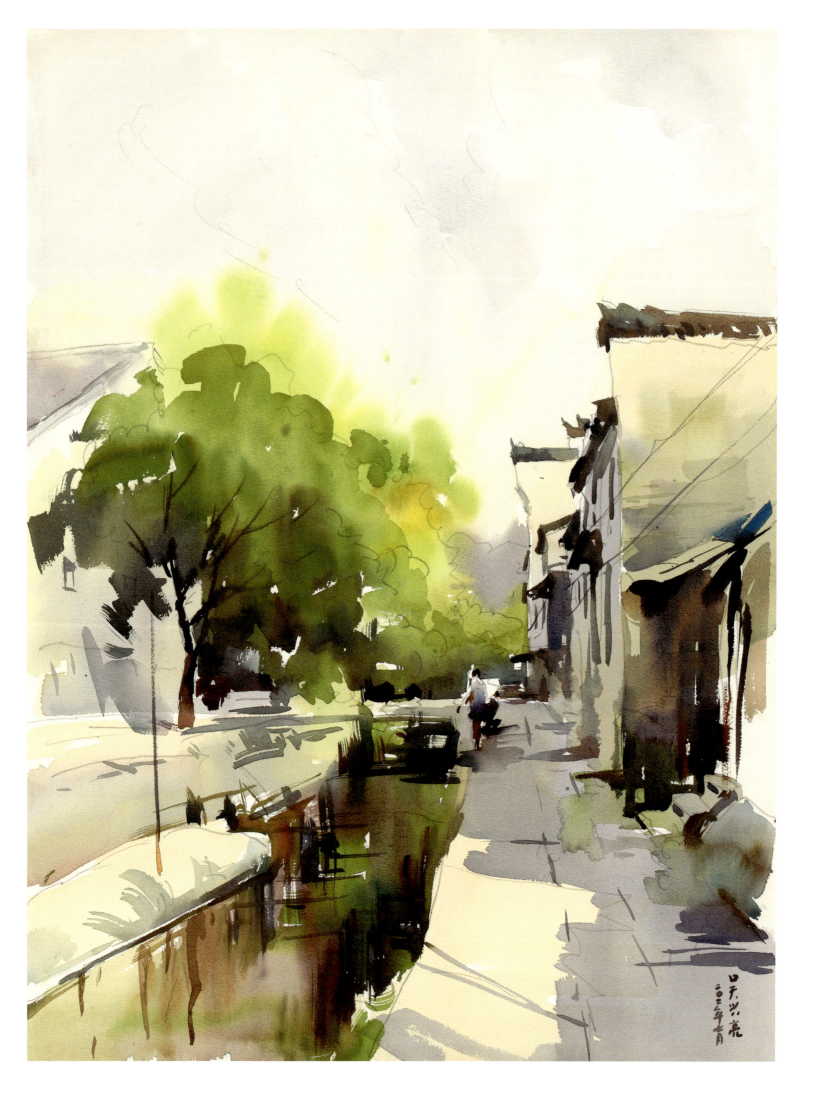

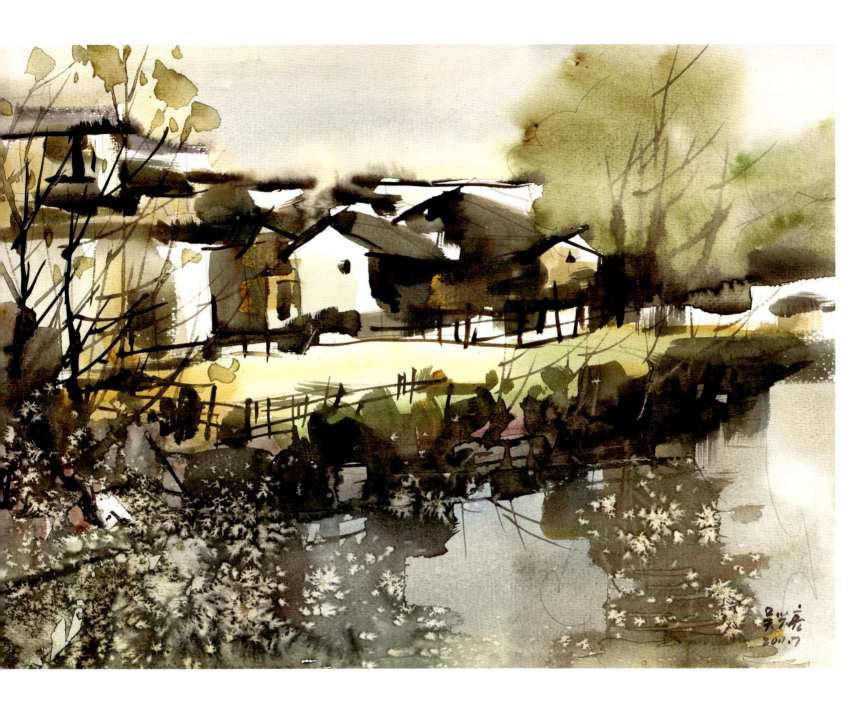

∧ 小河边　38cm×53cm　2011年　‖　On the Creek　38cm×53cm　2011

< 婺源村口　73cm×58cm　2011年　‖　A Village Entrance of Wuyuan County　73cm×58cm　2011

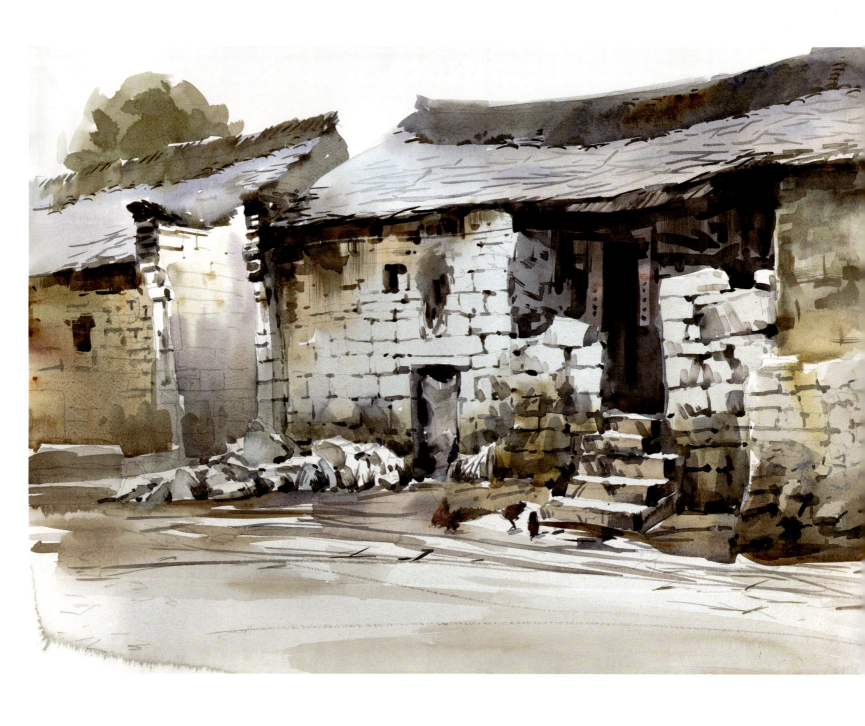

∧ 贵州石板房　73cm×58cm　2009年　‖　The Stone House in Guizhou Province　73cm×58cm　2009

﹥ 婺源晓起　53cm×38cm　2011年　‖　Morning Scene of Wuyuan County　53cm×38cm　2011

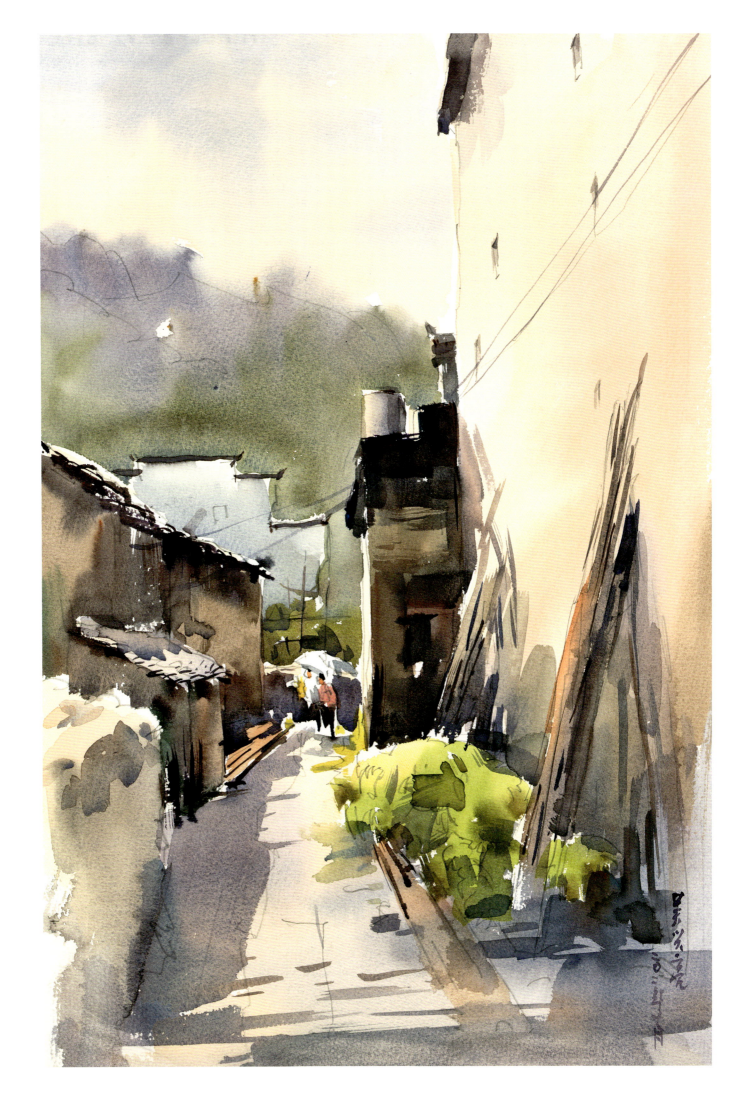

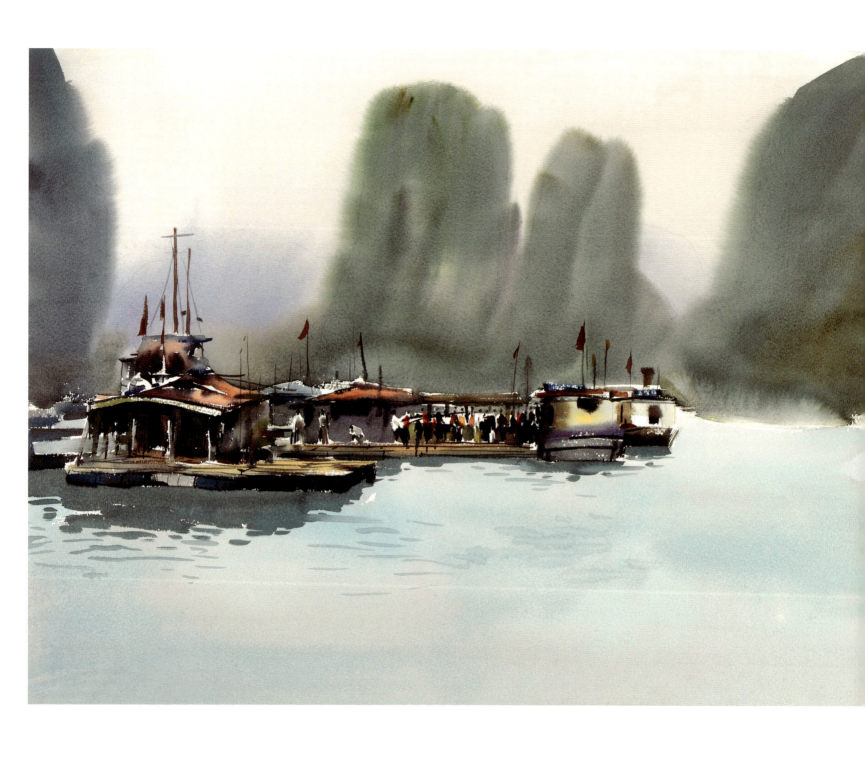

雨后越南下龙湾　54cm×73cm　2009年　‖　Halongbay after Rain　54cm×73cm　2009

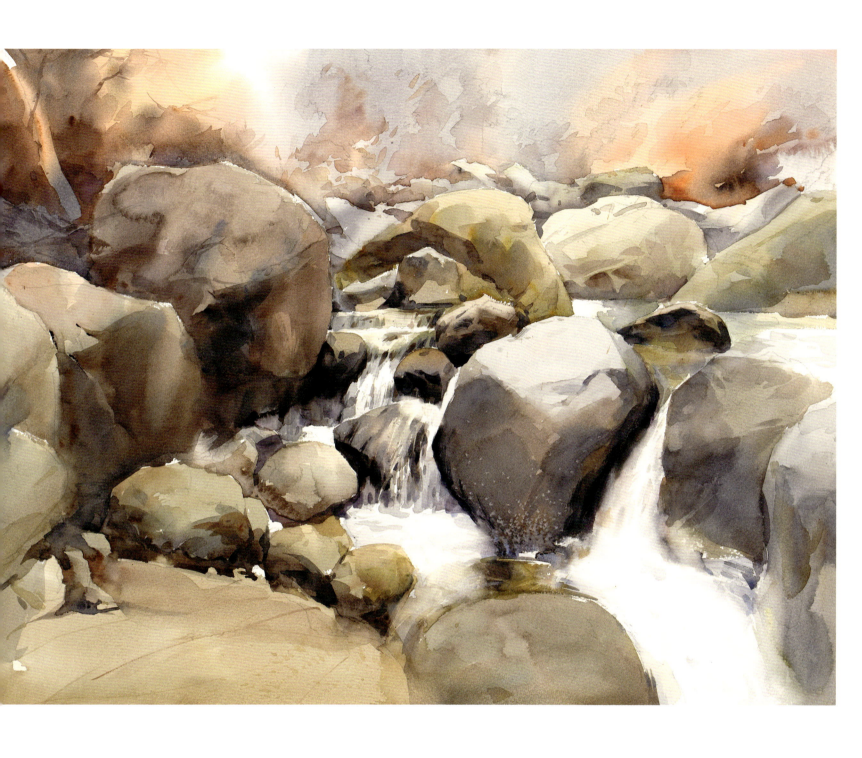

秋溪　53cm×75cm　2009年 ‖ A Brook in Autumn　53cm×75cm　2009

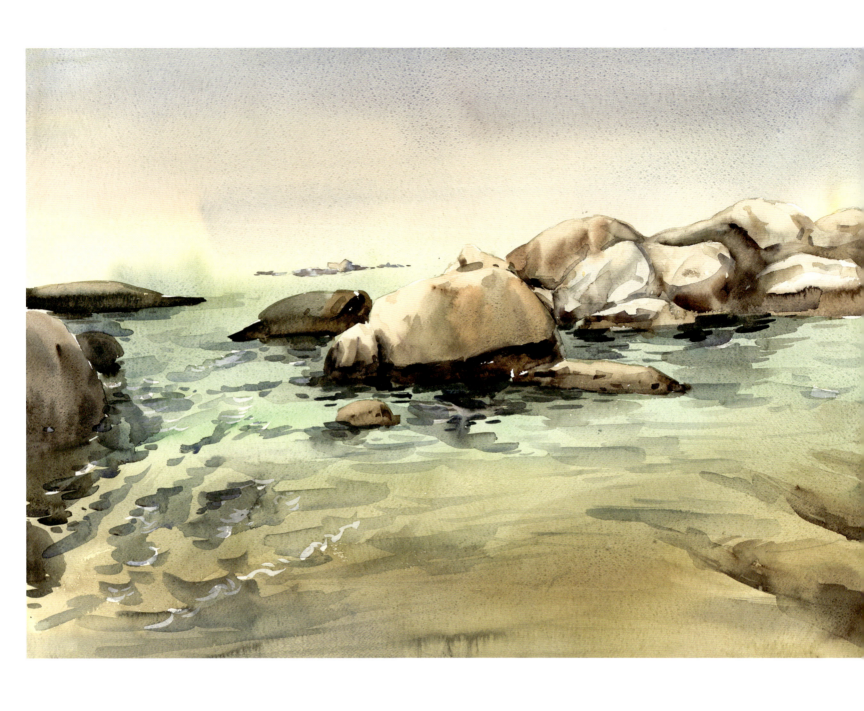

海南岛三亚礁石之一　54cm×73cm　2009年　‖　Reefs of Sanyan in Hainan Province (1)　54cm×73cm　2009

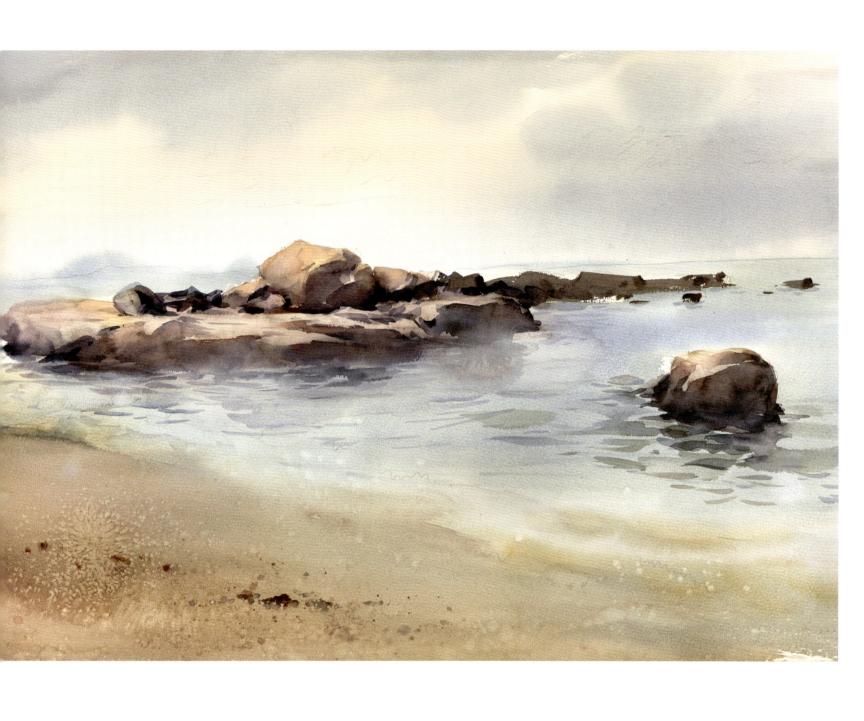

海南岛三亚礁石之二　54cm×73cm　2009年　‖　Reefs of Sanyan in Hainan Province (2)　54cm×73cm　2009

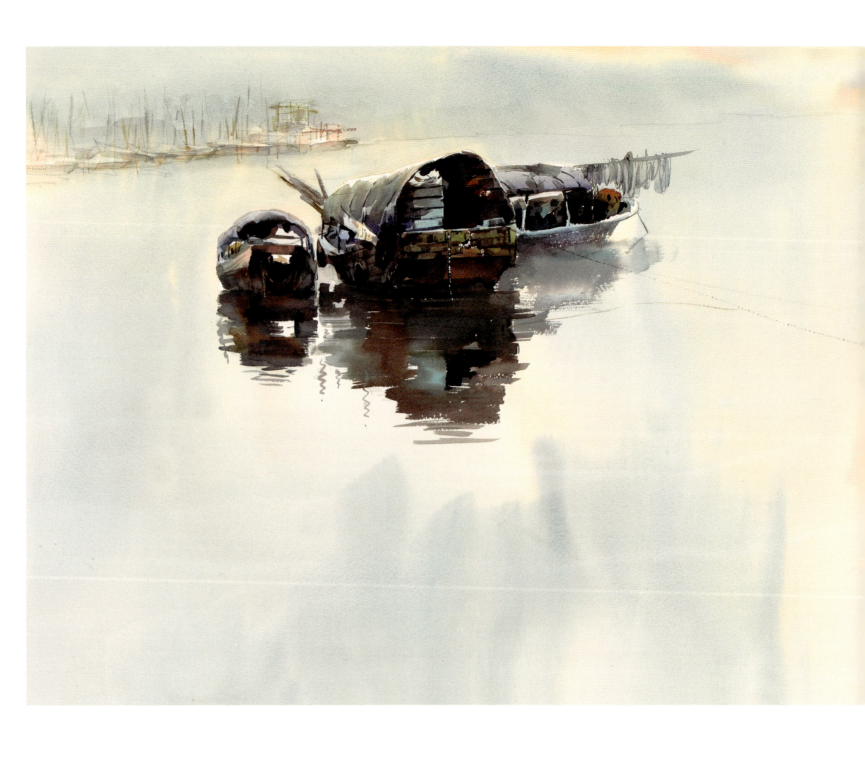

∧ 小渔船 54cm×73cm 2009年 ‖ Fishing Boats 54cm×73cm 2009

> 婺源小李坑 53cm×38cm 2011年 ‖ The Xiaolikeng Pit in Wuyuan County 53cm×38cm 2011

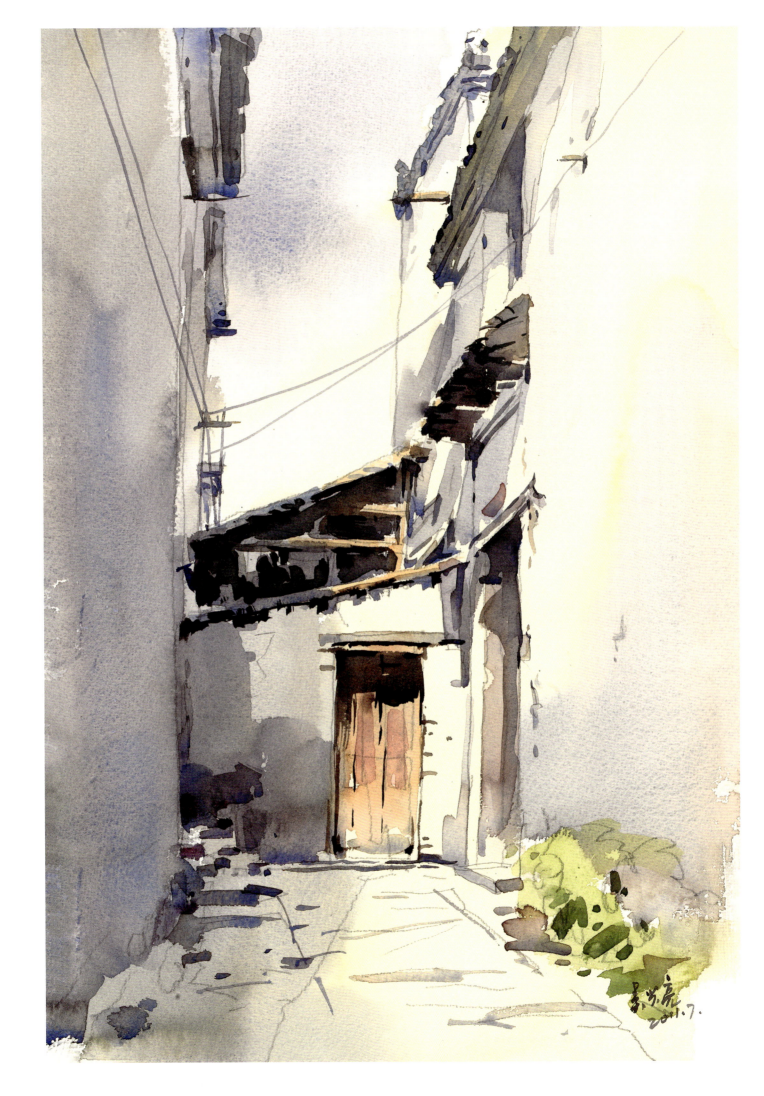

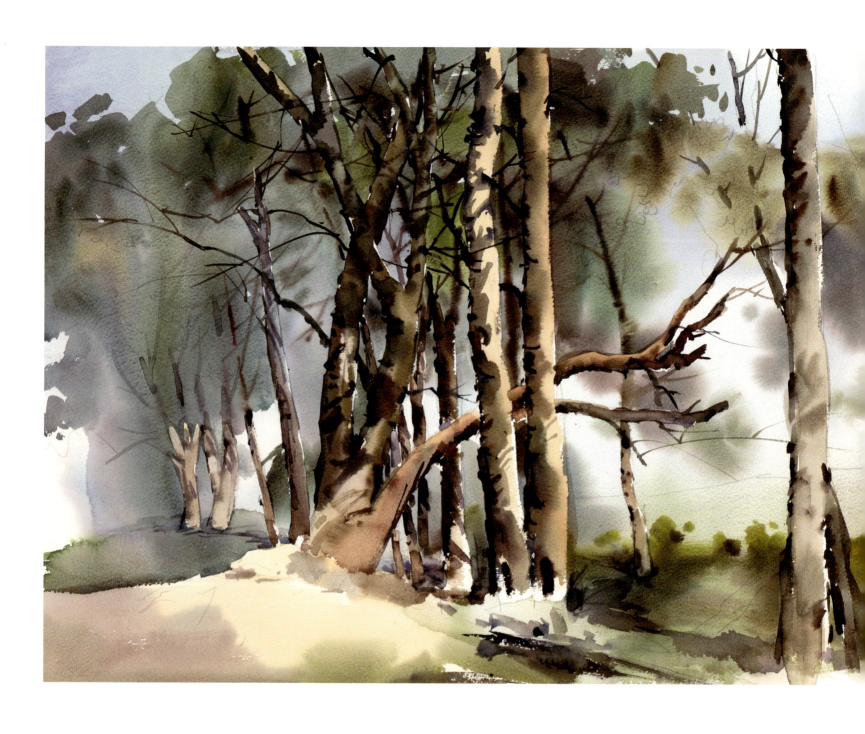

∧ 小树林　54cm×73cm　2009年　‖　A Grove　54cm×73cm　2009

> 屯堡巷子　73cm×54cm　2009年　‖　The Lane in a Tunpu Village　73cm×54cm　2009

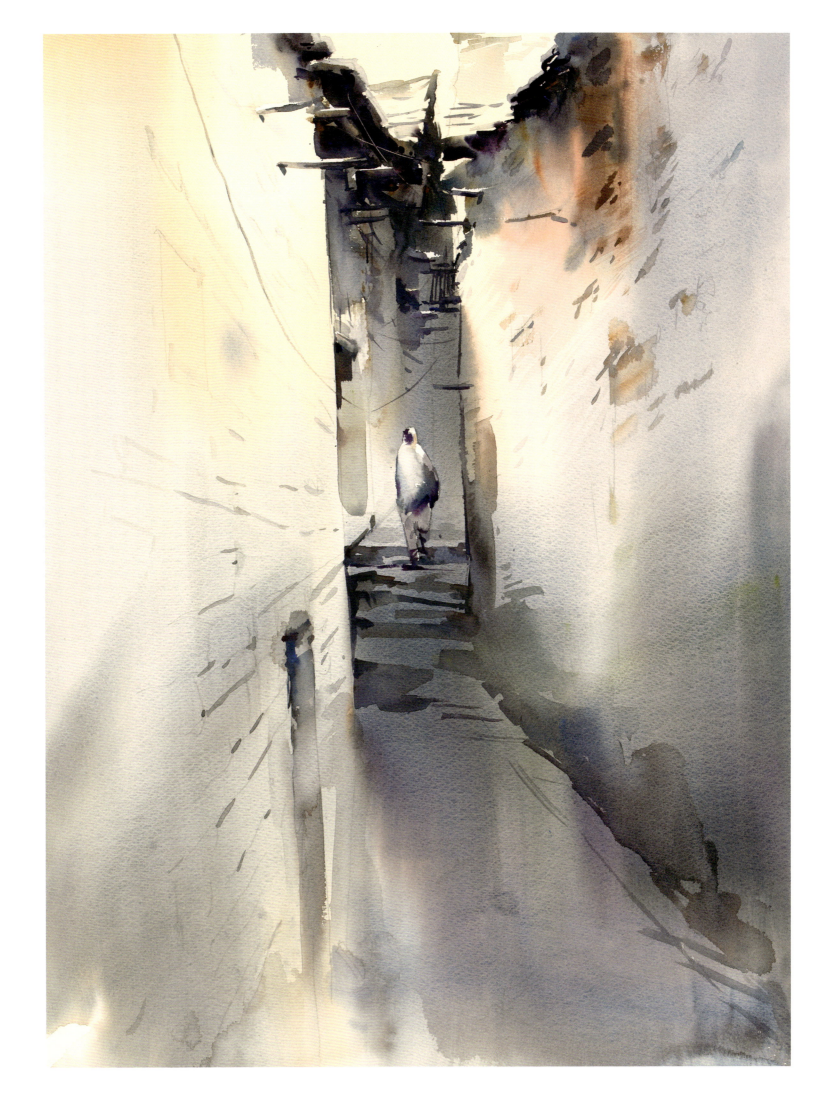

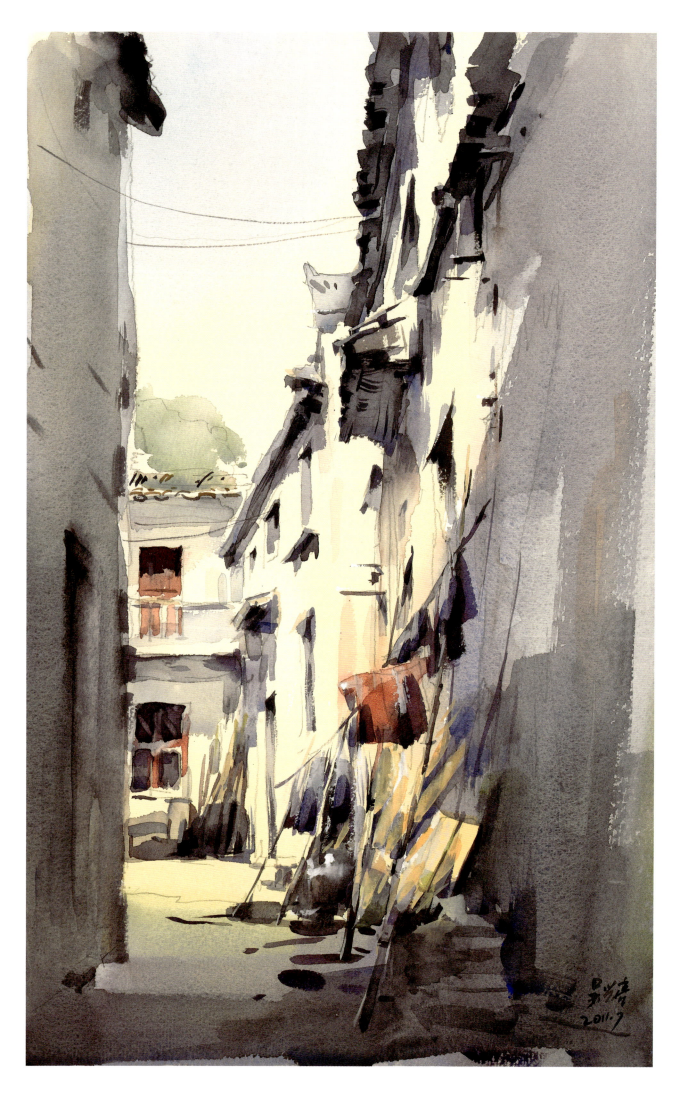

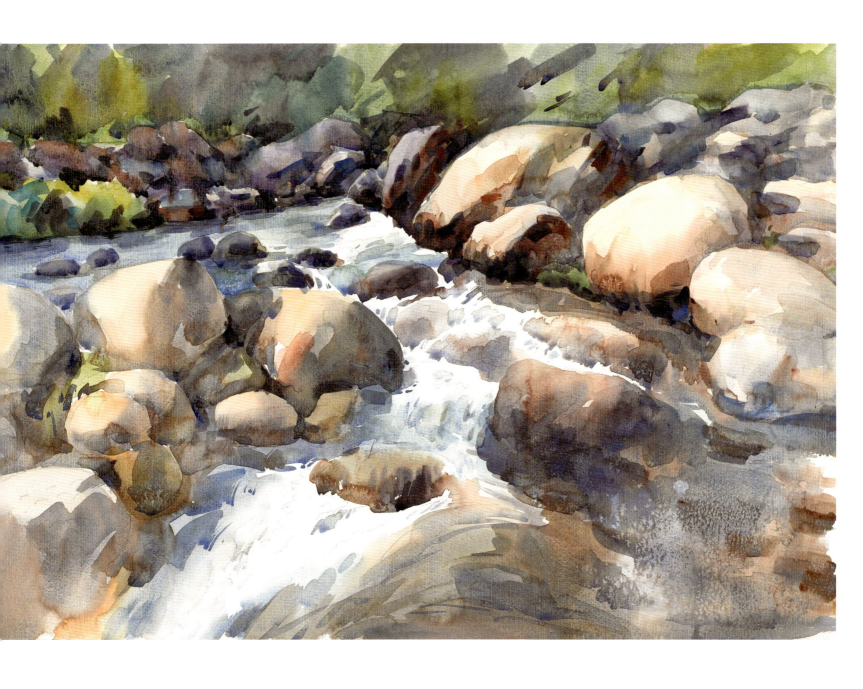

∧ 溪沟　54cm×73cm　2009年　‖　Rivulet　54cm×73cm　2009

< 婺源斜阳　54cm×38cm　2011年　‖　The Setting Sun of Wuyuan County　54cm×38cm　2011

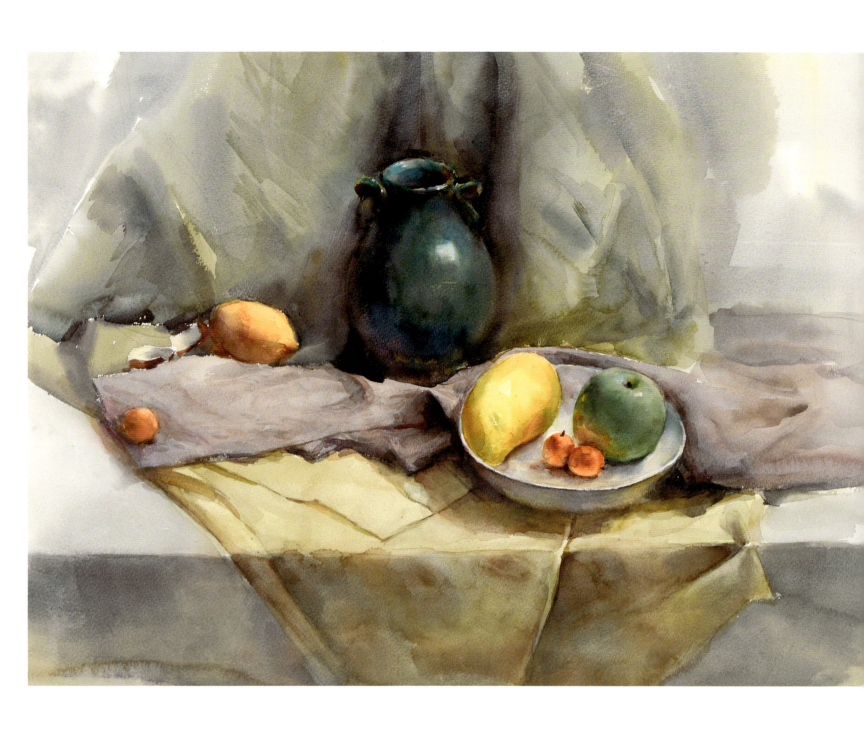

芒果与绿苹果　54cm×73cm　2009年　‖　Mango and Green Apple　54cm×73cm　2009

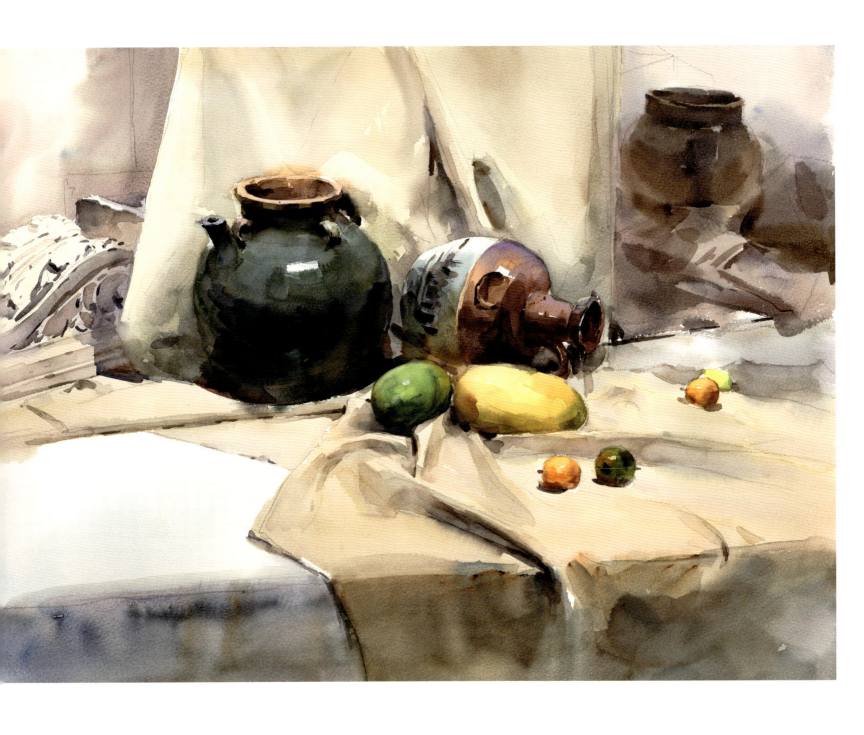

水果和罐的静物写生　54cm×73cm　2009年 ‖ Still life with Fruit and jar　54cm×73cm　2009

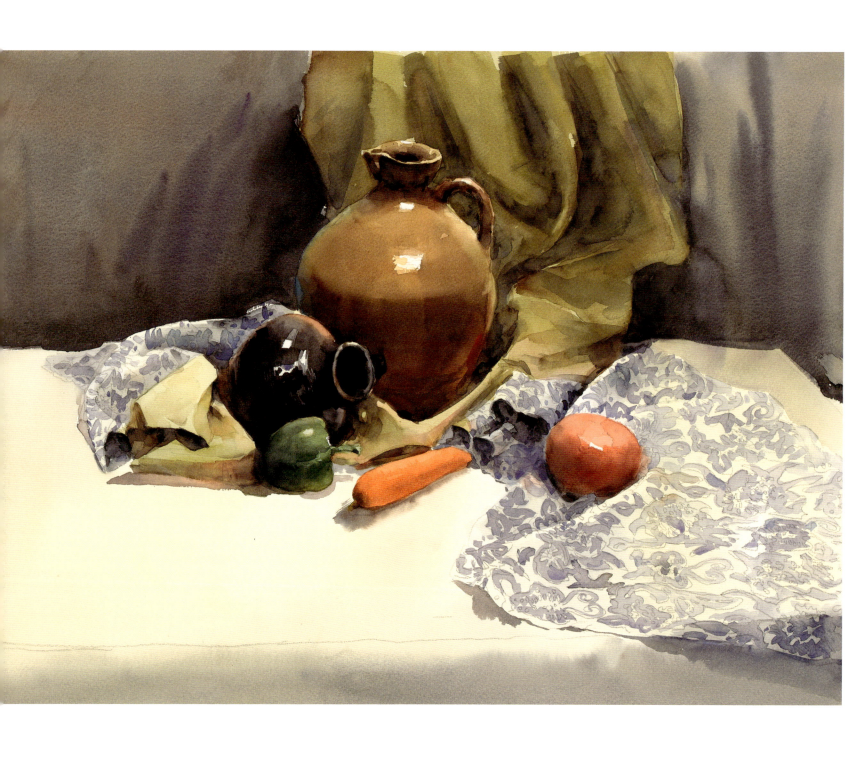

有蓝花布的静物　51cm×73cm　2009年　‖　Still Life on Orchid Cloth　51cm×73cm　2009

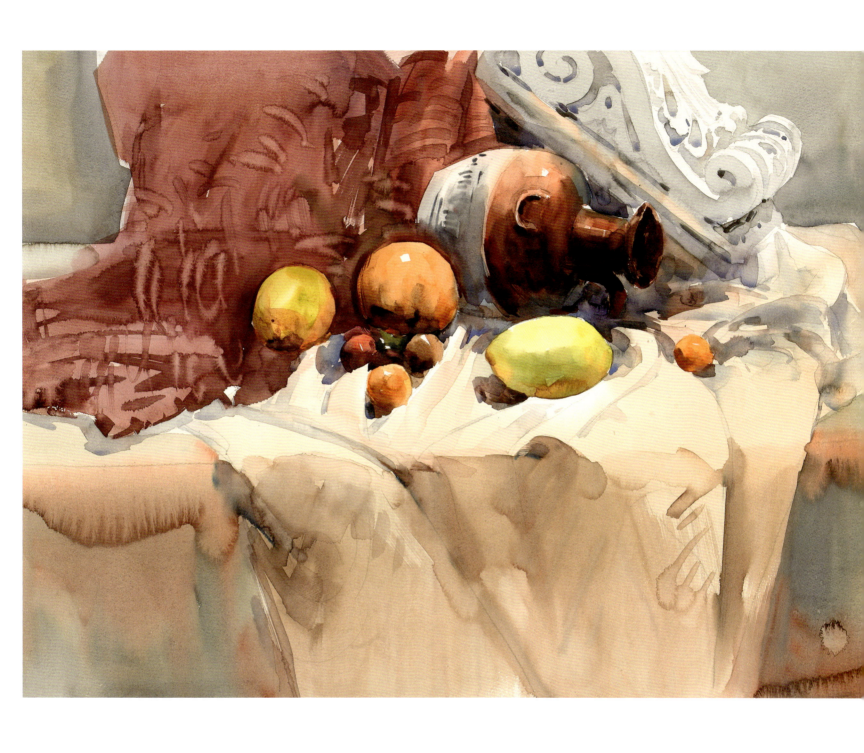

罐子与水果的静物写生　54cm×73cm　2009年　‖　Still life with Jar and Fruits　54cm×73cm　2009

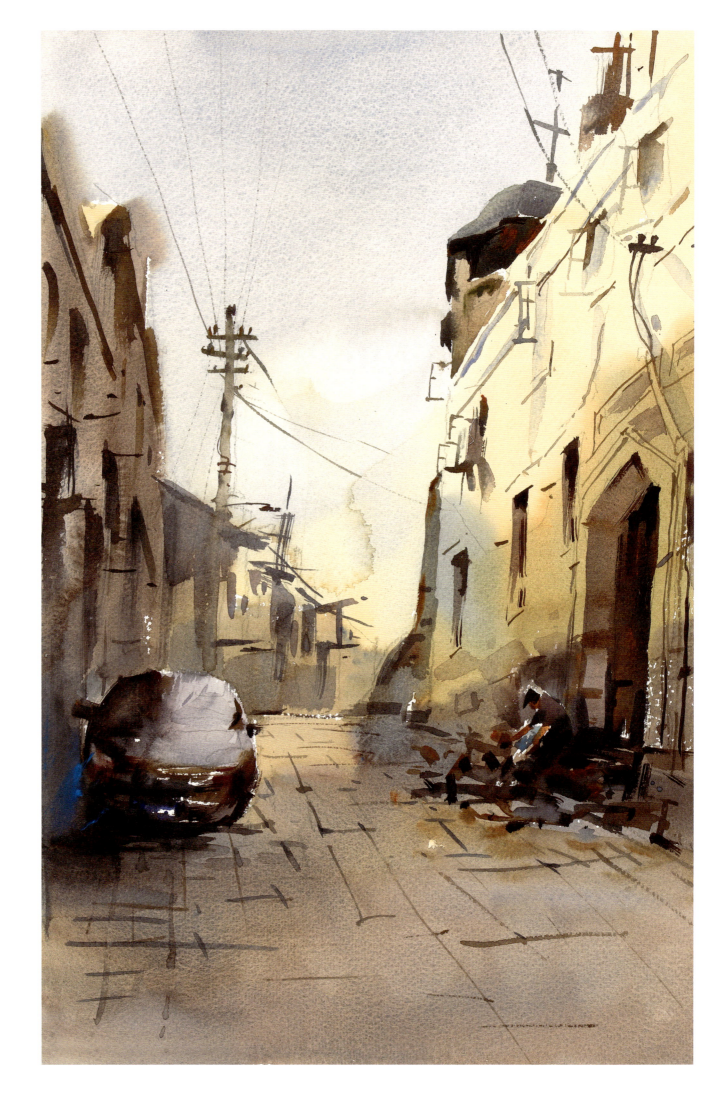

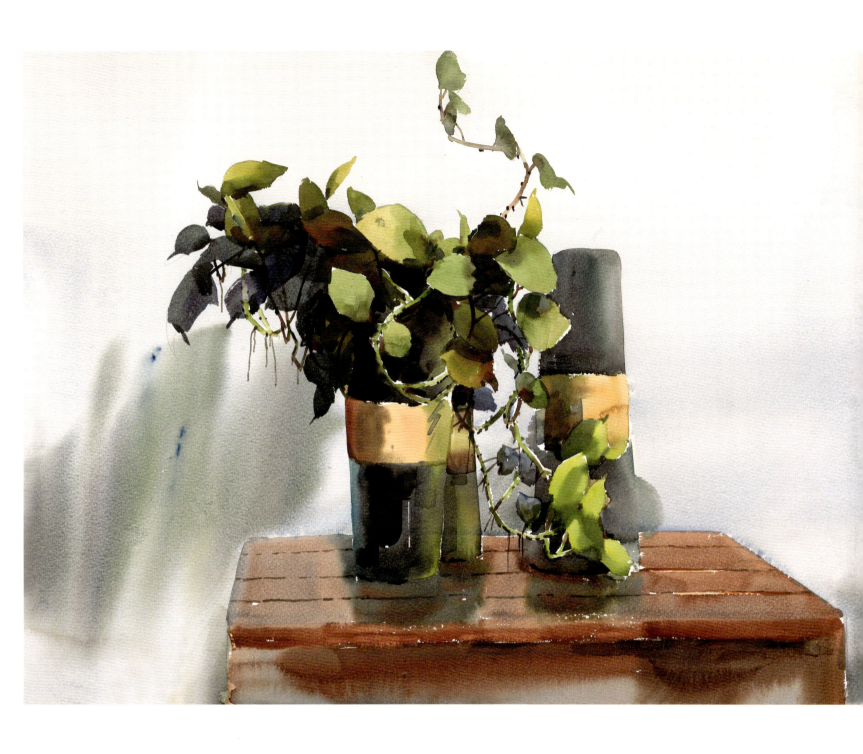

∧ 热带植物 51cm×73cm 2009年 ‖ Tropical Plants 51cm×73cm 2009

< 青岛建筑 53cm×38cm 2010年 ‖ Architecture in Qingdao City 53cm×38cm 2010

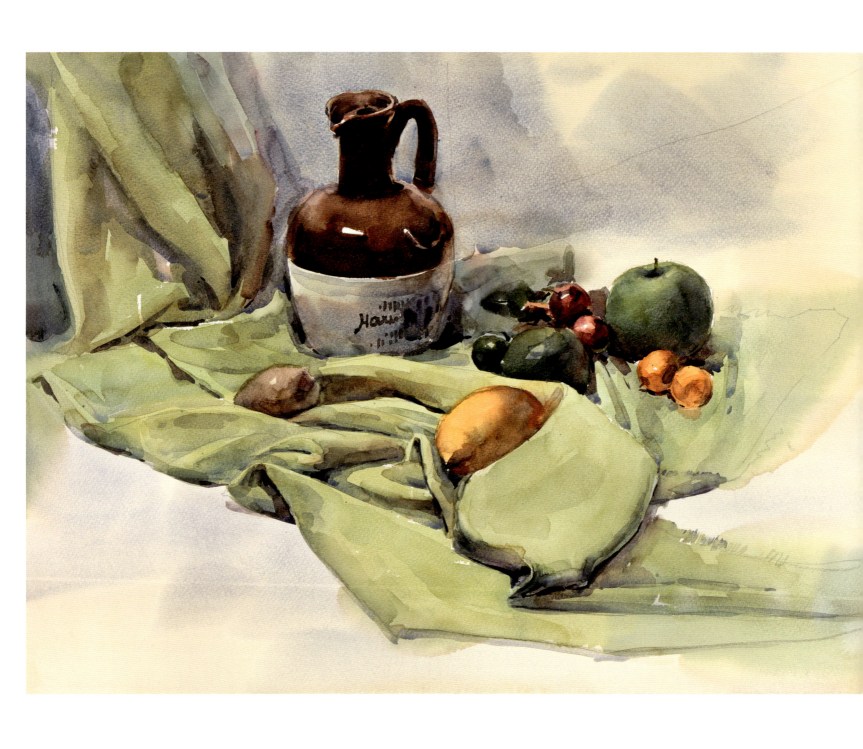

陶罐与水果　54cm×73cm　2009年　‖　Pottery and Fruits　54cm×73cm　2009

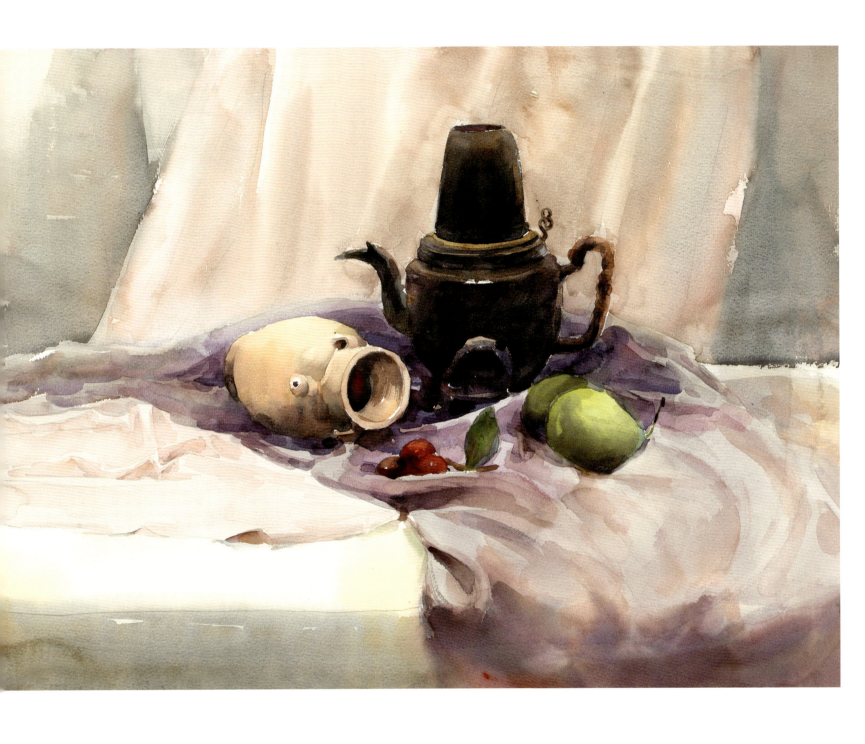

铜壶与罐子　54cm×73cm　2009年　‖　Copper Kettles and Mugs　54cm×73cm　2009

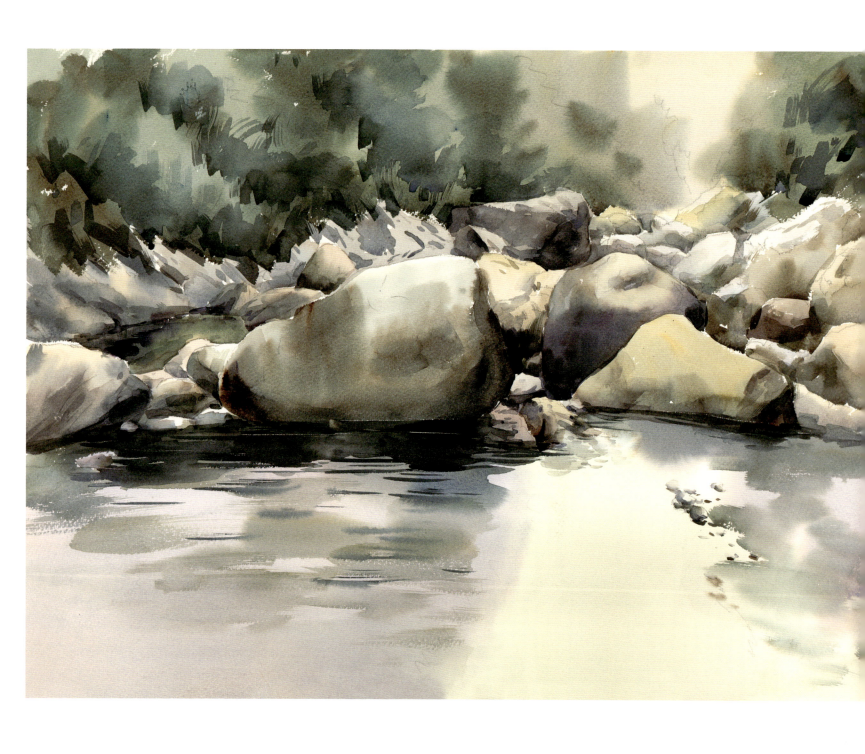

深山里的溪沟　54cm×73cm　2009年　‖　A Torrential Stream in High Mountain　54cm×73cm　2009

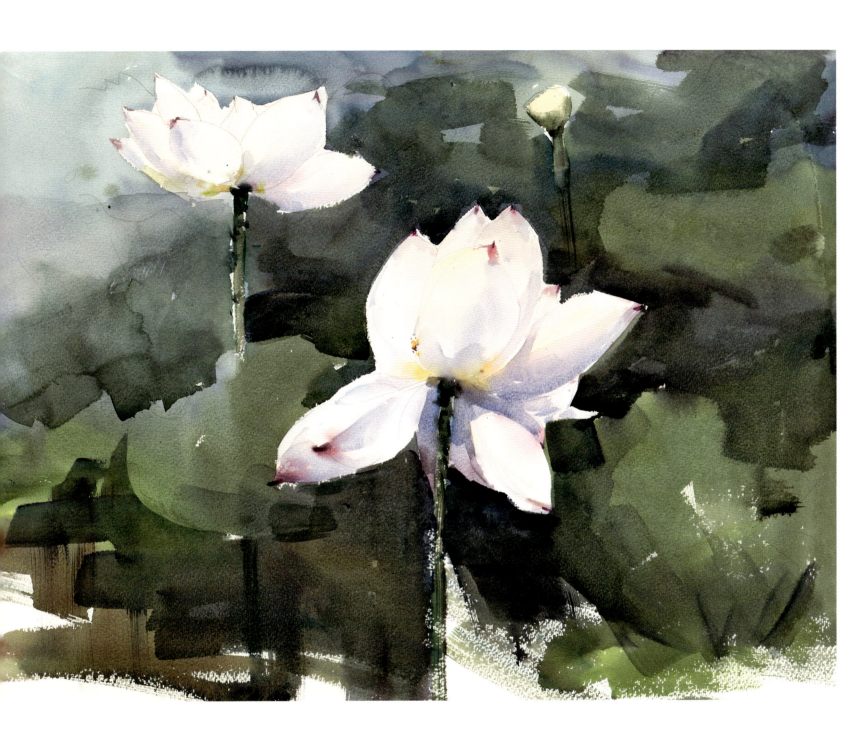

荷花 54cm×73cm 2009年 ‖ Lotus Flowers 54cm×73cm 2009

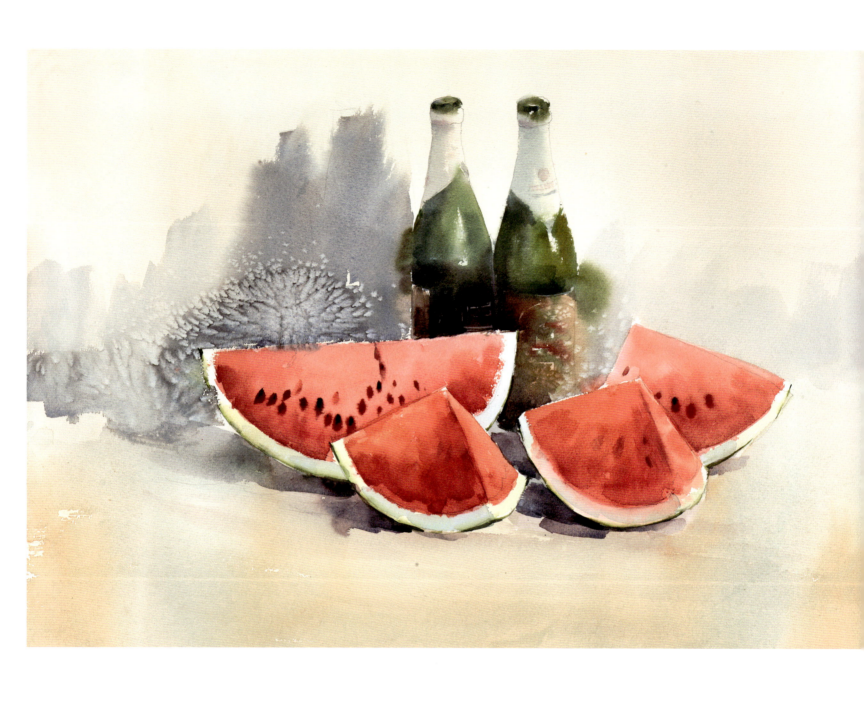

西瓜与啤酒瓶　48cm×73cm　2009年　‖　Watermelons and Beer Bottles　48cm×73cm　2009

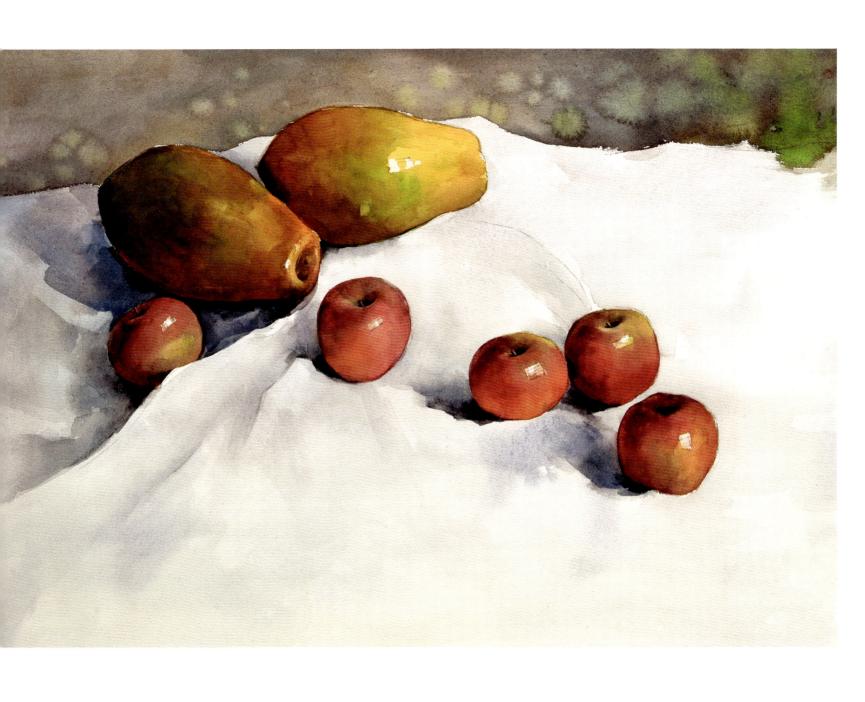

芒果与苹果　48cm×73cm　2009年　‖　Mangos and Apples　48cm×73cm　2009

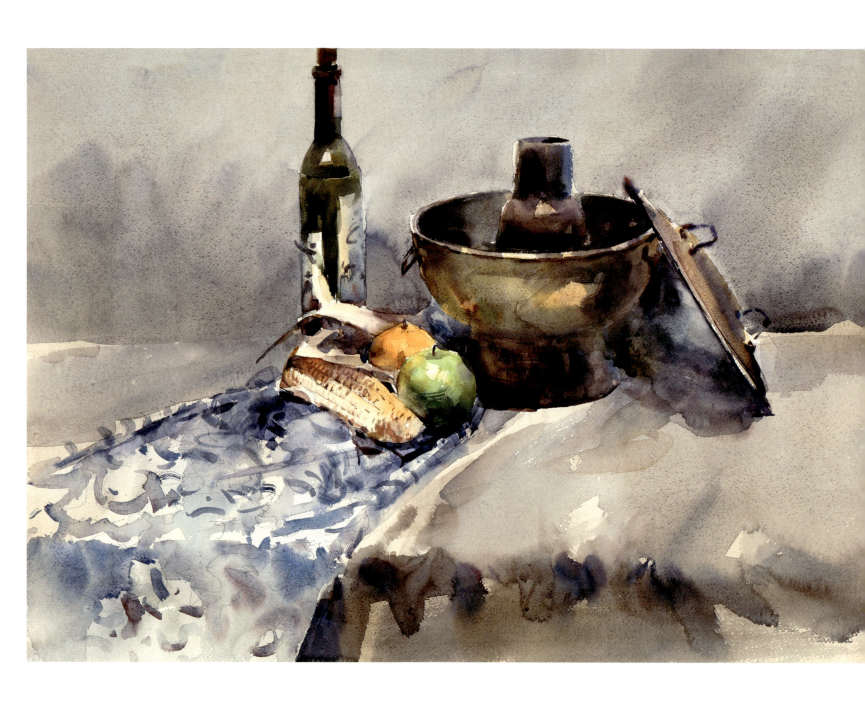

铜火锅　54cm×73cm　2009年　‖　A Copper Hotpot　54cm×73cm　2009

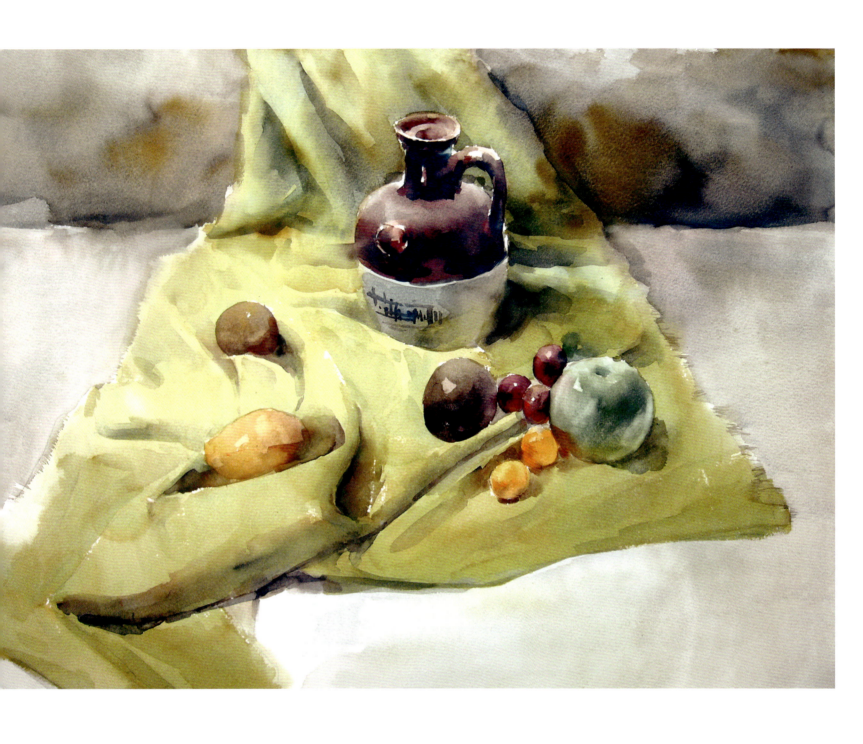

衬布 54cm×73cm 2009年 ‖ Lining Cloth 54cm×73cm 2009

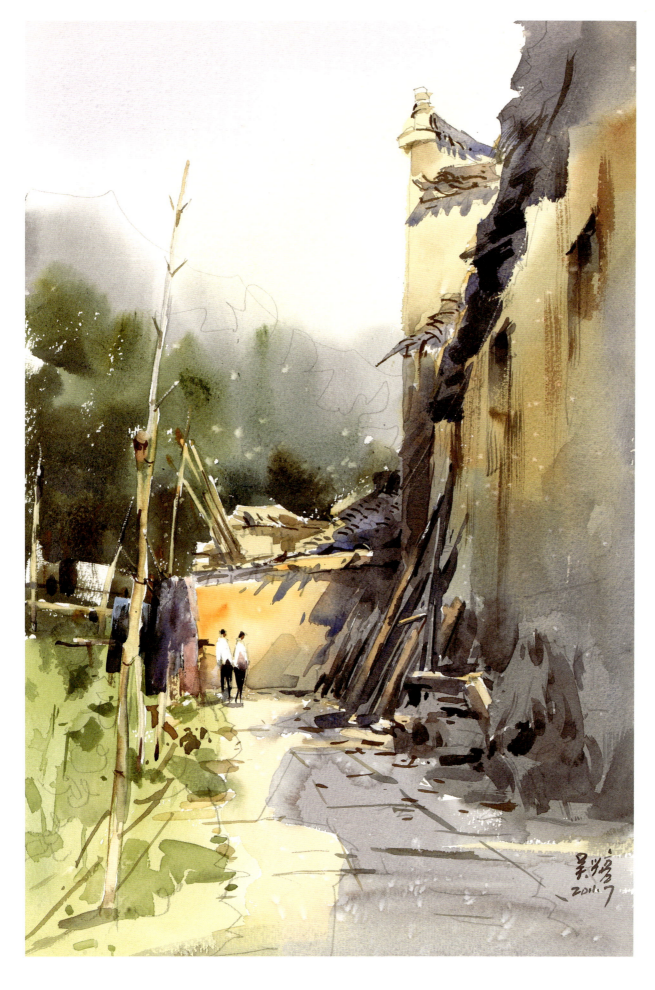

婺源小景之一　53cm×38cm　2011年　‖　Scene of Wuyuan County (1)　53cm×38cm　2011

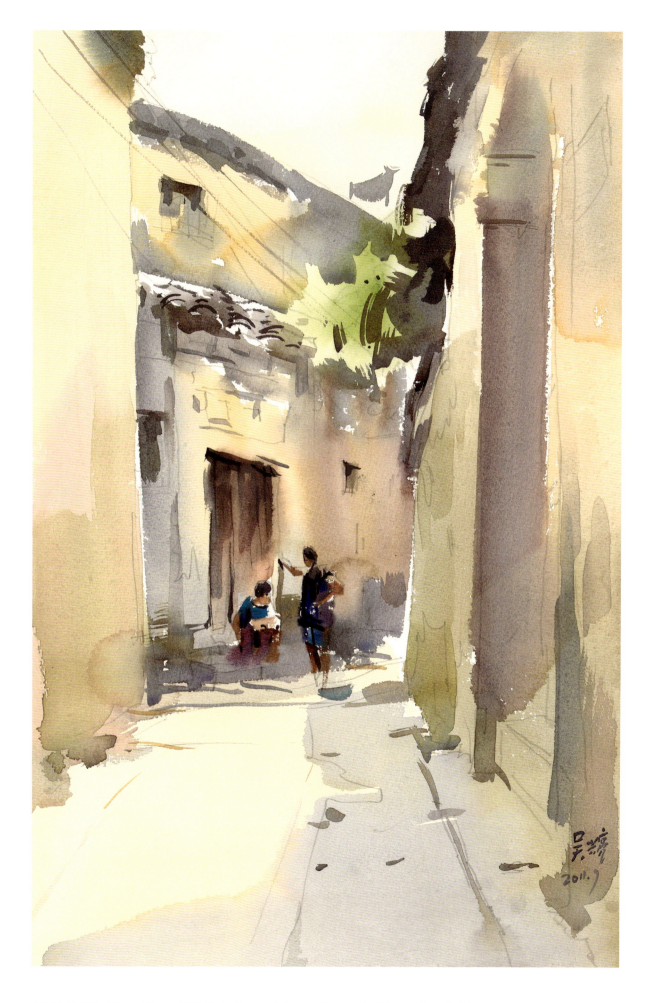

婺源小景之二　53cm×38cm　2011年 ‖ Scene of Wuyuan County (2)　53cm×38cm　2011

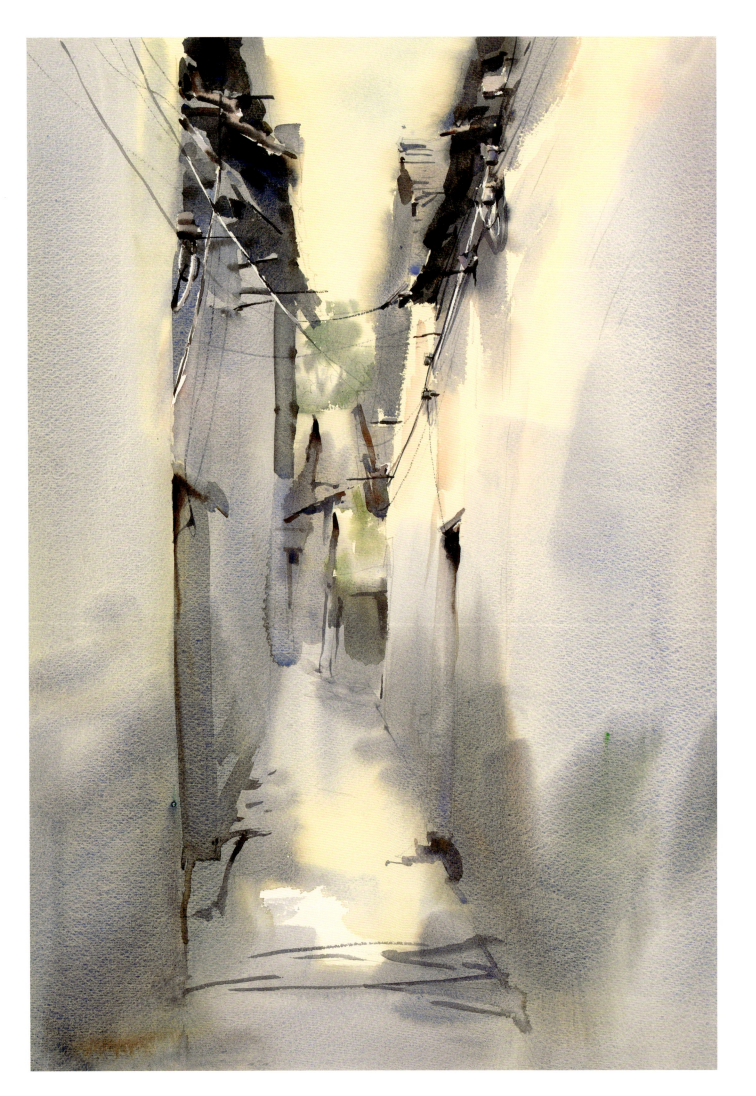

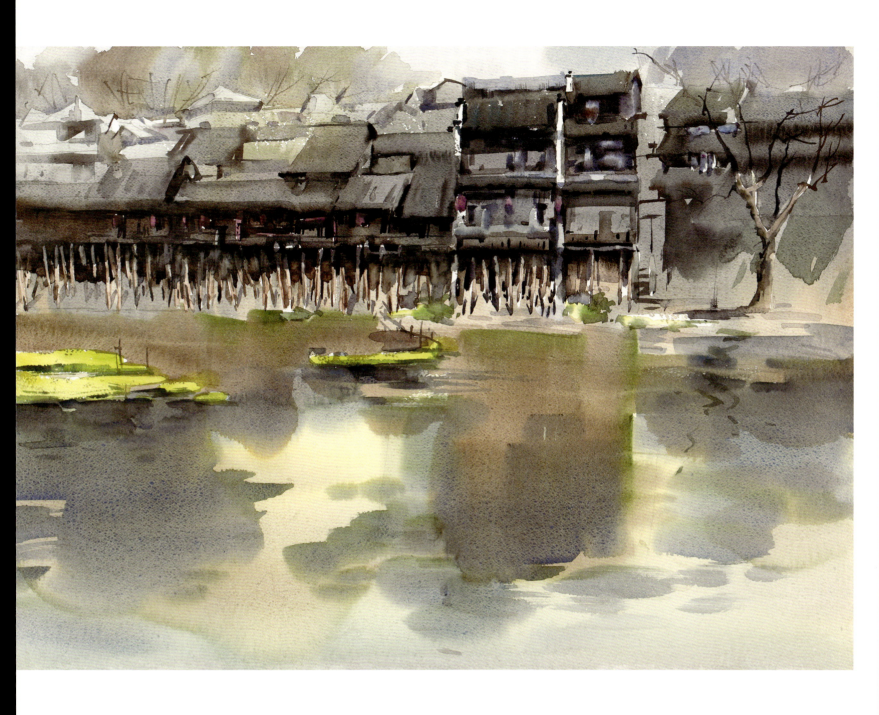

∧ 河岸　54cm×73cm　2009年　‖　River Bank　54cm×73cm　2009

< 巷子　73cm×53cm　2009年　‖　An Alley　73cm×53cm　2009

陶罐与红衬布　Pottery and Red Lining Cloth

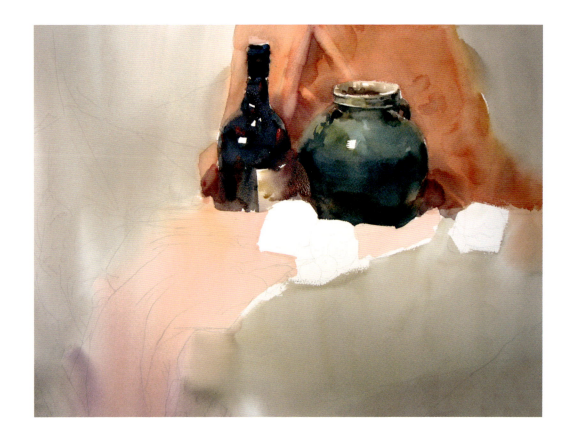

这幅画本着先背景后主体的原则。首先将陶罐、红衬布与水果空白后，调好大量的淡灰紫色，用大号画笔含水量较多的色彩大面积涂染，趁湿用饱和度高的颜色画红衬布和陶罐、酒瓶大致画出明暗交界线的位置关系，用水要多，追求淋漓生动，清新透明，用色要有微妙的变化，考虑到红衬布的影响，使用一些偏暖的灰颜色，用笔要干脆，特别是陶罐和酒瓶的明暗交界线用笔要准。

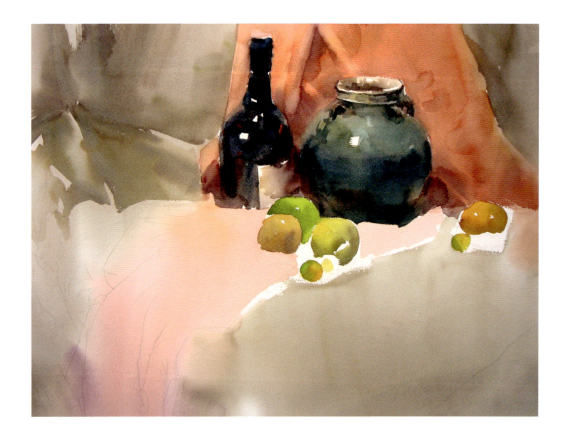

当第一层色彩未干时，趁湿画陶罐、酒瓶和红衬布第二遍颜色，着重表现背景衬布皱褶和陶罐、酒瓶的细部，调整形体结构关系，调整它们的明暗交界线的色彩关系，并画出红衬布上水果的大体色。画陶罐和酒瓶的暗部色彩时色彩不必调熟，可采用湿接的调色方法，酒瓶的色彩要考虑到画室的天光和绿色陶罐的的影响，使陶罐、酒瓶的受光和反光处产生了丰富的色彩变化

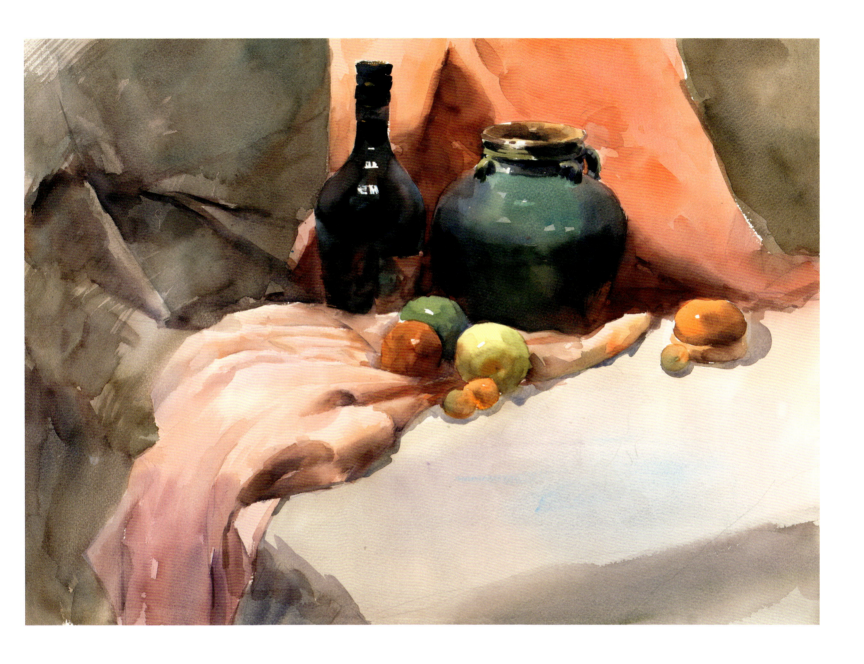

最后是调整阶段，进一步深入刻画陶罐、酒瓶、水果和红衬布的结构、色彩、质感、量感、虚实，调整它们形体结构、黑白灰关系和色彩变化。我们要注意画面中的陶罐、酒瓶、水果和红衬布在画室顶光的照耀下形成鲜明的对比，陶罐和酒瓶都受到红衬布的影响，加上水果的色彩，使整个画面呈暖调子。对陶罐和酒瓶的刻画运用了干画多层覆盖的技法，表现出陶罐和酒瓶的重量。在笔触、水分、色彩和时间的掌握的基础上，把主体和背景，整体色彩冷暖，明暗关系中补色的关系进行反复比较，而且整个绘画过程中必须趁画面湿润时着色，有时一笔含两色，色彩自然渗透，确保色彩浑厚、层次丰富。

水彩静物速写　Sketch of Still Life in Watercolor

水彩画速写多用湿画法。用2B铅笔起稿，画出准确的形体后，迅速抓住物体色彩的倾向，用大号笔把调好的含有充足水分的暖灰色在纸上涂染，留出空白玻璃器皿、水果桌面上衬布，趁湿画出背景衬布和陶罐的大体关系，运笔准确干脆，一气呵成，力求表现水彩画的润味。

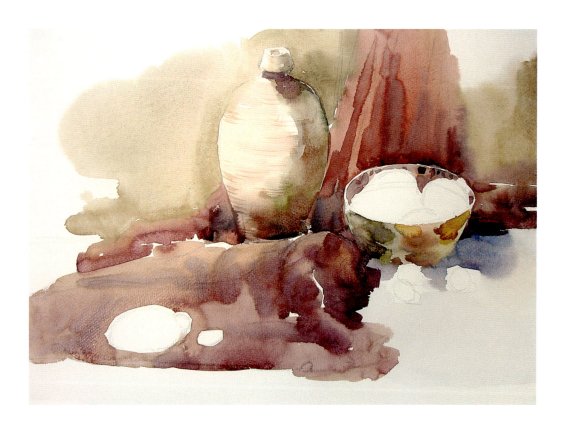

趁湿画陶罐的出明暗关系、地面衬布和玻璃器皿，画陶罐时第一次色要很湿，水分要足，第二次上色时，笔上颜色要多，但水分要稍干，相互渗透产生过渡，使得陶罐浑厚圆滑。趁半干半湿画出背景立面和地面的衬布褶皱。

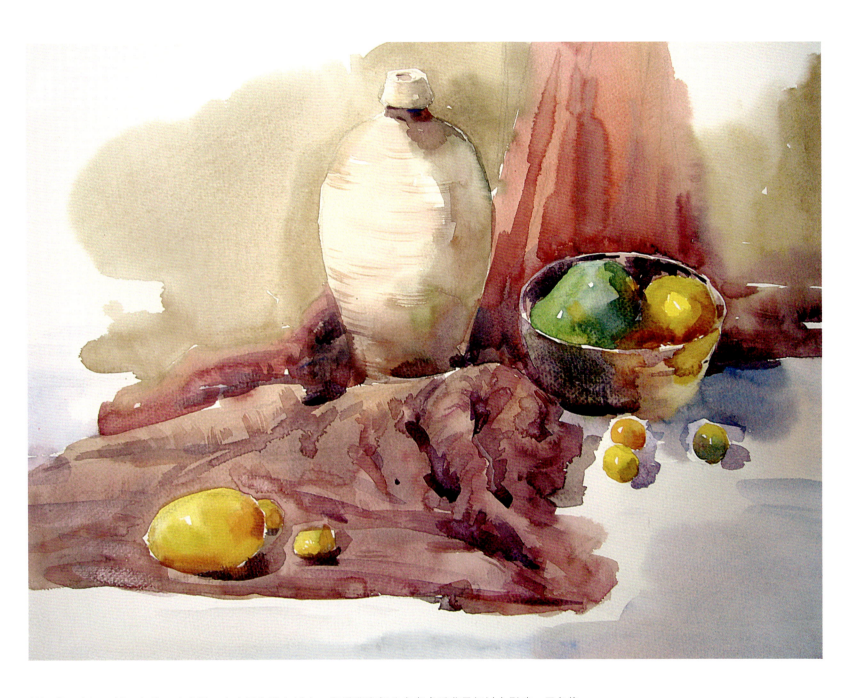

趁湿进一步深入刻画陶罐、玻璃器皿中水果和地上衬布,陶罐背光部分应考虑受背景红衬布影响,用色偏暖,刻画受光部和背光部的色彩微妙变化。用笔触画衬布,上第二遍颜色时,一定要趁湿画上去,水分要把握住,这样才能表现织物柔和的质感和微妙的变化。画玻璃器皿中水果时,要考虑到玻璃透明度及环境色对器皿的影响。用大笔调兰紫灰色画地面和投影,并调整画面的整体明暗变化和色彩变化关系。

热带水果　Tropical Fruits

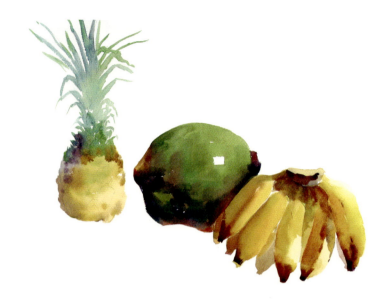

这幅画本着先主体后背景的原则表现热带水果的画面。先画菠萝，画菠萝要注意菠萝的结构。菠萝似松果状，上面有无数螺旋着生的小格子和叶片。在画菠萝格纹时，不要一格一格的画小格子，只需要用湿画法画出菠萝圆筒形的明暗关系。随后画椰子和香蕉，用纯度较高的颜色画椰子和香蕉大体的明暗关系。

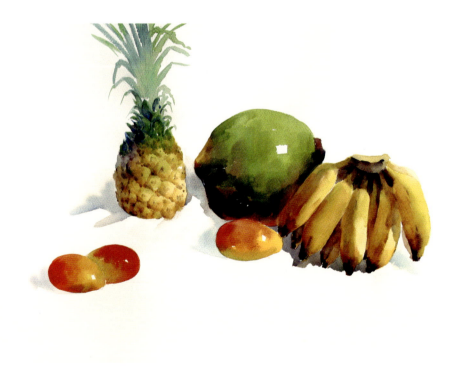

接下来刻画菠萝的亮部。暗部的要虚，注意圆筒形上部的暗部受环境影响偏紫灰色。画叶片时注意着生的方式，其色彩要单纯，不宜丰富。菠萝处于整个画面的远处，刻画时不要画过，要留有余地。接着刻画椰子、香蕉和芒果。

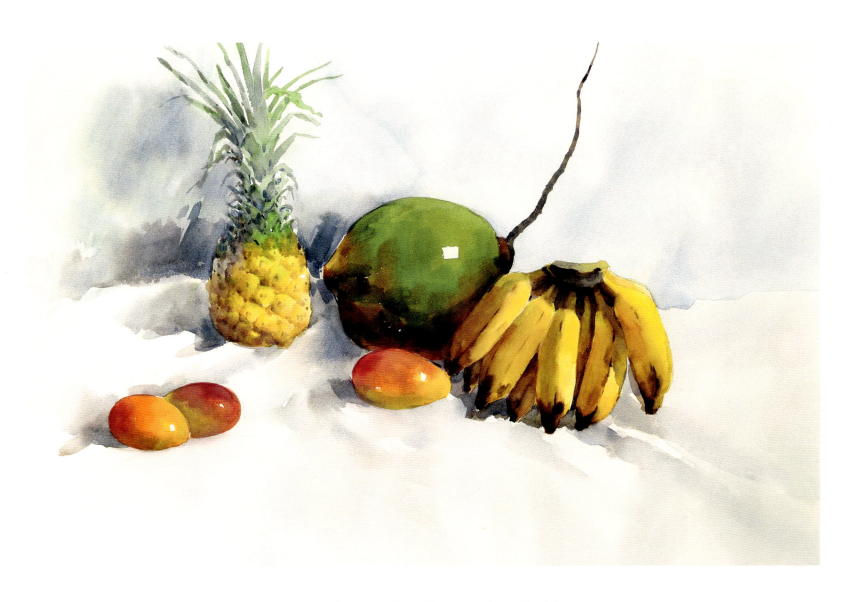

在主体水果基本画完后,色彩关系正确的基础上,对画面的进行全面调整和完善,用干画法深入刻画出水果的质感,整个过程要保持水彩画的湿润。菠萝、香蕉和芒果的色彩相互影响和呼应,椰子与其它水果的明度形成对比,最后画背景和衬布,简单的白衬布突出了热带水果。

寓理于画　臻于至善
——记吴兴亮教授的水彩艺术

中国著名科学家钱学森先生认为："科学技术工作者要有一点儿文学艺术素养，因为创新往往源自猜想，可以说科学工作是源于形象思维，而终于逻辑思维；而文学艺术家要懂一点儿科学知识，才会有一个正确的世界观，才会用正确的方法论指导艺术创作。"吴兴亮教授是一位在自然科学和水彩艺术领域都有所建树的学者，享受国务院有特殊贡献的政府特殊津贴。他曾出版了多部重量级的学术著作，主持多项国家自然科学基金资助项目，获得多项教育部和省政府科学技术成果奖，他的科学创新与成就很大程度也受艺术上的启迪或影响。吴兴亮教授早期受工作环境影响对水彩艺术产生了浓厚的感情，师从著名水彩画家、原中国水彩画会副会长田宇高教授。一直未间断对水彩艺术创作和技法的探索，水彩画作品在《美术》《中国水彩》《中国画家》等期刊上发表，并曾获中国美术家协会举办的美术展览优秀作品奖。2005年，他主编了我国第一部高等院校园林专业美术系列教材《园林水彩》，重印达20000册；在2007年出版个人画集《水彩艺术表现》。更可贵的是已经功成名就的吴兴亮教授能够放下一切名利，在百忙之中，于2009——2010年到清华大学建筑学院做高级访问学者，跟随导师高冬教授，潜心研究水彩艺术，对水彩艺术和表现技法都有了新的认识和提高，其绘画理念也有了明显的改变和提升，为进一步的研究水彩艺术打下了深厚的基础。他在一年之中绘画作品几百张，并在清华大学举办了清华大学建筑学院高级访问学者"吴兴亮水彩画作品展"。展出获得一致好评，我国中国科学院院士、中国工程院院士、著名的城市规划及建筑学家、教育家吴良镛先生观看展览后说，他特别喜欢吴兴亮教授所画的风景和花卉。最近他的一批学术性的水彩画精品——《吴兴亮水彩艺术》教材，由清华大学主编入选全国高校"名师绘画技法系列丛书"。

作为一位自然科学家和水彩画家，吴兴亮教授对于水彩有他自己的观点和坚持，在我看来也是一种他融合进水彩中的科学观和方法论。

一、水彩语言的坚守和拓展

吴兴亮教授是一位传统水彩的守望者，他以一位科学家的敏锐视角审视水彩艺术，对水彩的艺术语言去伪存真。他认为水彩语言的本体一个是水，一个是彩。水色交融和渗透，产生空灵、明净、流动、洒脱的独特之美，他作品的色彩有一种美玉的温润感。吴兴亮教授的水彩画以湿画法为主，特别强调画面的润泽感。水彩手法干净利落，分寸把握恰到好处，色彩润而不单，水分泽而不流。他的水彩静物作品《白玉兰》，没有使用遮挡液等特殊技法，洁白的花朵是留空出来的，可贵的是画面背景依然一气呵成、色调典雅，而且在润泽的氛围中我们可以感受到空气的贯穿流动，花香四溢。在场面较大的风景水彩作品表现中，吴兴亮教授依然坚守着水味润泽的水彩本体语言，他的水彩风景写生作品《北欧风光》采用湿画法运用不同的蓝色一挥而就，快速而连贯地运笔，利用水与色的溶化，扩散达到形神兼备的效果。画面中天空云层翻滚，云朵的受光面和投影过渡自然，充分表现出云朵厚重又轻盈的体积。水面上波光粼粼，作者用横向用笔在底色的不同湿润状态下，将在流动的波光云影中映照

的建筑运用印象的手法表现出来。吴兴亮教授创作的《泊》《船》，用笔奔放，水色交融，淋漓酣畅。画面风格简约质朴，水分淋漓又不失于轻浮，在水色之中见神韵，充分发扬了水彩画的特长。《船》曾代表中国的优秀水彩画作品在"2010亚洲国际水彩画大展"中展出，受到国外朋友们的好评。

吴兴亮教授曾对我说过："不论水彩其内容、形式还是表现的精神和意境上如何改变，水彩中的水味，它的色彩的润泽感应该是要永远保留的，因为这是水彩的根本。"在坚守这一原则的同时，他也尝试在中国画语言中寻找可以为我所用的养分。

看吴兴亮教授的水彩画，感到淋漓酣畅，挥洒自如，颇有中国写意画之风韵。他研究水彩画与中国水墨画的亲缘关系，认为中国画中的没骨画法实际上也是一种"水彩画"，都是以水为媒介的画种，在技法和表现效果上颇有相似之处。他探索水彩画"气韵生动"的精神潜质，在最新作品《婺源风景》系列中融入了水墨写意画的轻松畅快，用笔苍劲老辣、气丰韵足。同时将西画中的光影在提按、顺逆、快慢、转折、正侧、藏露等变化多端的用笔中自然的表现出来。

二、精益求精的钻研

吴兴亮教授探索"水彩画民族化"，坚守水彩润泽的水味。同时，他对于水彩画面的其它基本构成也非常重视。他在初学水彩时，为了更好地掌握水彩技法，广泛地学习了素描、油画、版画、中国画等基础和相邻画种。在清华大学做高级访问学者时，他又以科研攻关的态度和行动，按照导师高冬教授为他量身定制的课程内容，从素描的造型、结构和表现等方面入手深入实践和研究，使自己的水彩在造型、结构和色彩的素描关系上更为严谨科学。在静物作品《果盘和罐的静物写生》《陶罐与红衬布》《芒果与绿苹果》等等中，我们可以清晰明了的看到水彩静物色彩与素描关系：画面的构图丰满协调，主体突出，特别是深度空间在虚实对比中得以加强。画面中静物的结构结实有分量感，质感分明。静物和衬布环境在色彩明度对比中很响亮，并且色调也统一和谐。面对这些赏心悦目的作品大家可知，吴兴亮教授在绘画静物水彩稿之前，都曾认真严谨的进行了静物素描写生。一位著名美术家观看吴兴亮教授水彩画作品后对他评论"他有分寸地吸收外来的养分，孤注一掷地按照自己的理念工作着，潇洒地、愉快地用水彩的本体语言挥动画笔。他对水彩画本体语言的操守，重视水彩画独特的审美感染力，达到异乎寻常的程度。他严格地把握水彩的正宗画法，不为时尚所困，使用娴熟、高难度的传统技能，充分表达了水彩美的特色。多年来，乐此不疲，他的本职工作是生物学研究,画水彩画，对他来说是赏心悦目，故他没有争名夺利之想，正是这种'无心插柳'的行为，反而出现'柳成荫'的现状"。

色彩与素描关系也被吴兴亮教授成功地运用到了他的水彩风景写生作品中。建筑是风景画中最难表现的内容之一，吴兴亮教授曾经跟随田宇高教授无数次在苗寨、侗寨、布依寨和江南水乡描绘过不同民族风格的建筑，那一时期

绘画重点多放在表现水味和色彩，而近期的作品受高冬教授的影响，在建筑物的表现角度上更注重结构和光影。吴兴亮教授的作品《青岛红房子》有别于他之前的风景建筑画，色彩显现出一种阳光下的响亮对比。天空和地面的冷色对比中，景中建筑物的暖色使景物更为突出，严谨的建筑结构和透视，又使得画面耐人细观。吴兴亮教授为了画面既有水味润泽，又能更注重精准的表现结构，他在其他人休息的时候又独自去画了第二遍，这无疑是将精益求精的科研精神放在对水彩的追求上了。近作《婺源景色》系列更将吴兴亮教授作品追求的简洁、写意、神似、空灵、疏朗、透明、轻快等特点充分表现。高大的墙面以大笔丰色湿画，寥寥几笔，将南方湿润的气质表现的一览无遗。构图采用H型竖构图，两边高耸的白墙却将窄巷挤压出纵深感，斑驳的光影在墙头上又将巷子闭塞的空气打开了。

三、寄情于物的植物水彩

吴兴亮教授是一位著名的自然科学家，他对大自然的感情是深厚的。这也催生了他的水彩画中一种以自然植物为描绘对象的水彩作品。而这些作品却是最打动我的，不仅因为吴兴亮教授以科学家的素养对植物的生态属性极为熟悉，更是因为他作为画家用画笔表达的是自己对植物的一种真爱。例如他的画作《清华荷塘》，他并没有和多数人一样选择芳洁的荷花作为描绘主题，而是独辟蹊径地选择了常常作为陪衬的荷叶。但是，圆圆的荷叶在他笔下是如此可爱，没有荷花的傲洁，有的是一种平凡的美。看似随意的构图其实是画家精心的剪裁，荷叶聚集在画面上部，下半部分是映照在水面的天光云影，原本两部分景物色彩在明度上很接近，吴兴亮教授精心地将几片莲叶的投影重重地摆在了最恰当的地方，不但改变了构图的五五平分，也从素描关系上稳定了画面，更映衬出荷叶的体积，对比出水面上明净的天光云影。

再完美的内容和形式都要依靠画家的感受和表达才能成为打动人心的作品，因为艺术的最高境界是表达哲理，陈述世界观。吴兴亮教授的植物水彩不强调炫目的技巧，他注重的是植物本身的生命状态，在作品《花的静物写生》中，他表现出北方的紫丁香在隐忍了一个寒冬后，嗅到春天温暖的气息，怒放的生命欢歌，因为它的美只有一个星期。相比之《紫玉兰》就是一件从从容容的作品了，它表达的是一种内心的坚定和自在，年年花开年年花落，每年的我依然热情不减，美丽依然。吴兴亮教授在植物上的科学素养为他的植物水彩画增添了一种理性意味的魅力。就连随处可见的小树搬到吴兴亮教授的画面中都会变得别有一番情调，《小树林》里几棵歪歪扭扭的小树，就像调皮可爱的孩子，又那么富有生命力。作品《树》以一个简单的字命名，挺直的树干仿佛是一排干净利落的哨兵。

不可否认，吴兴亮教授在水彩艺术中融进了一位自然科学家对真理的坚守、对科学的执着、对知识的运用。科学与艺术的结合不是简单的结合，而是文理相通、辩证统一的结合，我只能从水彩艺术中的科学运用这一个角度试图去剖析吴兴亮教授的水彩艺术魅力。伴随着他对水彩画技法的实践和钻研，相信吴兴亮教授在水彩艺术的绘画理念和表现技法上会日趋纯熟，吴家美玉将琢成！

高花君

2011年10月